ELEMENTS OF PAINTING SERIES

ENERGIZE
Your PAINTINGS *With*
COLOR

LEWIS BARRETT LEHRMAN

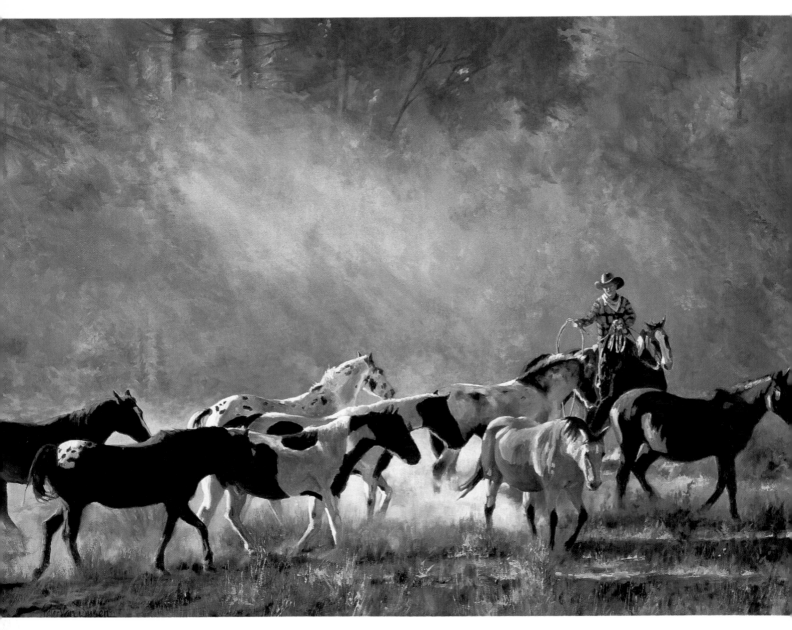

Evening Roundup
Peter Van Dusen
Oil on canvas
30" × 40"

ELEMENTS OF PAINTING SERIES

ENERGIZE
Your PAINTINGS *With*
COLOR

LEWIS BARRETT LEHRMAN

NORTH
LIGHT
BOOKS

Cincinnati, Ohio

About the Author

Watercolorist/author Lew Lehrman comes to fine art following nearly three decades in commercial art and illustration. Together with his wife, Lola, the Lehrmans ran Design Unlimited until 1984. It was a graphic design and food service consulting firm known nationally as one of the most creative firms in its field. These days the Lehrmans reside in Scottsdale, Arizona, having recently sold their home and the art gallery they both operated in the Berkshires of western Massachusetts. Lew's first book, *Being An Artist*, was published by North Light Books in 1992. It was inspired by his own interest in learning what it takes to become a self-supporting, professional fine artist in today's world.

Lew received his graphics and fine art education at Carnegie Institute of Technology, and at Pratt Institute in New York. Lew's work is currently on exhibit at galleries in Arizona, Connecticut, New York and Massachusetts.

Energize Your Paintings With Color. Copyright © 1993 by Lewis Barrett Lehrman. All rights reserved. No part of this book may be reproduced in any form or by any electronic or mechanical means including information storage and retrieval systems without permission in writing from the publisher, except by a reviewer, who may quote brief passages in a review. Published by North Light Books, an imprint of F&W Publications, Inc., 1507 Dana Avenue, Cincinnati, Ohio 45207. 1-800-289-0963. First edition.

Printed and bound in Hong Kong.

97 96 95 94 93 5 4 3 2 1

Library of Congress Cataloging-in-Publication Data

Lehrman, Lewis Barrett.
 Energize your paintings with color / Lewis Barrett Lehrman. — 1st ed.
 p. cm.—(Elements of painting series)
 Includes index.
 ISBN 0-89134-476-4
 1. Color in art. 2. Painting—Technique. I. Title II. Series: Elements of painting.
ND1488.L43 1993
752—dc20 93-3764
 CIP

Thanks to each artist for permission to use interviews and art.

Edited by Rachel Wolf
Designed by Paul Neff

METRIC CONVERSION CHART		
TO CONVERT	**TO**	**MULTIPLY BY**
Inches	Centimeters	2.54
Centimeters	Inches	0.4
Feet	Centimeters	30.5
Centimeters	Feet	0.03
Yards	Meters	0.9
Meters	Yards	1.1
Sq. Inches	Sq. Centimeters	6.45
Sq. Centimeters	Sq. Inches	0.16
Sq. Feet	Sq. Meters	0.09
Sq. Meters	Sq. Feet	10.8
Sq. Yards	Sq. Meters	0.8
Sq. Meters	Sq. Yards	1.2
Pounds	Kilograms	0.45
Kilograms	Pounds	2.2
Ounces	Grams	28.4
Grams	Ounces	0.04

Dedication

To the artist, whose chosen task it is to teach the world how to see.

To you who wield that potent force — creativity — which offers humanity its best hope.

To each person who brings something into being that did not exist before: a painting, a song, a solution, a child.

To the teachers . . . to the learners . . . to all who do . . . and all who build.

To you whose creativity is kindled anew each day by the works of The Supreme Creator.

Acknowledgments

The author would like to thank the following people, without whose particular contributions this book would never have seen the light of day:

First and foremost, my wife, Lola, who continues to support my own still-formative creative efforts. My thanks, also, to all those artists who so graciously and patiently allowed me to watch them at work, videotaping, photographing, and asking far too many questions. Thanks also to Ann Morrow, and the ever-helpful staff at The Scottsdale Artists' School.

Finally, much gratitude to my editors, Rachel Wolf and Greg Albert, and the people behind the scenes at North Light Books who, by the time you read this, will have turned mere words and photos into a living, breathing book!

— Lewis Barrett Lehrman

Contents

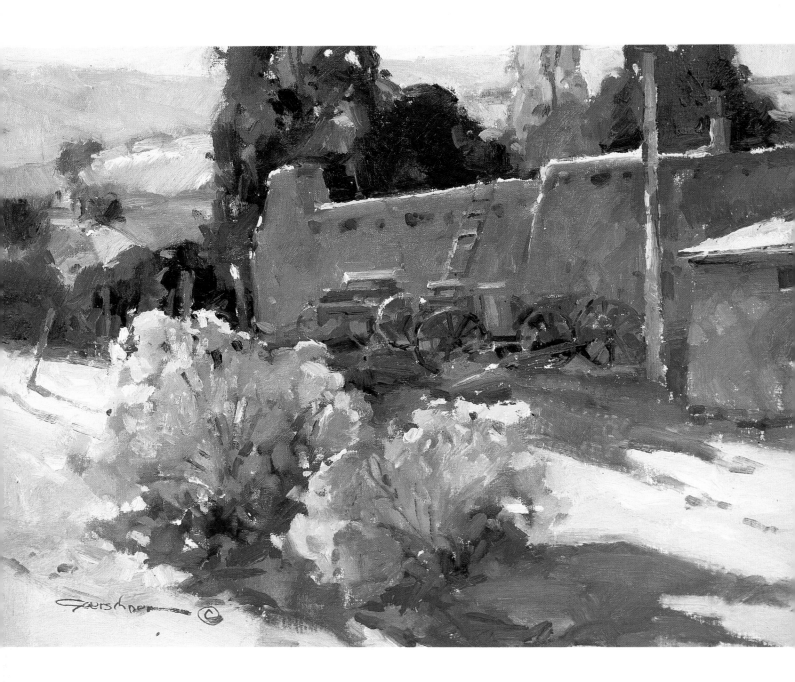

Introduction

The Art Within the Art

We have all experienced that moment of discovery in a gallery or museum — coming upon a work that seems to radiate an inner light, exerting its power on us, triggering emotions, evoking memories, creating feelings we cannot express in words.

What is the art within the art that creates this energy?

Artists, whose study of their craft is truly never-ending, will offer many answers: form, composition, symbolism, emotion — to name a few. But most will include, as a prime component, color.

Few aspects of the visual experience are as instinctively pleasurable as the perception of color. And that's quite fortunate, too, since our eyes are assaulted by color every minute of the day — so continuously, and so intensely, in fact, that we are often completely unaware of our responses to it.

Physicists, psychologists and anthropologists devote entire careers to studying the ways in which we perceive, interpret and react to color. Color is used to influence our choices at the supermarket, to warn us of danger, to draw attention in advertising, to soothe, to excite, to entertain and to educate. Newspapers bloom with color. And what do we expect to see in every magazine and on every TV screen? Color!

To explore the ways in which today's artists are using color to energize their work, I approached a number of talented professionals. They graciously shared with me their time, their experience and their insight. As I photographed their paintings in progress, I asked the questions I thought you might ask, and I have conveyed to you their answers.

Aware of the power of the living picture in depicting a process, I videotaped the demonstrations, and transcribed them with the playback before me. That's why much of each demo is written in the artist's own voice, with my comments added. In effect, I've tried to present you with twelve videos in book form.

Each demo was a unique opportunity to observe the mind, as well as the hand, of the artist at work, and I've tried to convey that essence in these pages. I think you'll find their approaches relevant to your own work, regardless of whether their chosen medium coincides with yours.

Before plunging in, a personal note: Early in my own artistic development, I bought all the newest watercolor books, read them from cover to cover, and wondered why my painting didn't improve. It was only when I began to take the time to actually *do* the demonstration paintings, step-by-step with the open book beside me, that I began to learn. A revelation! Painting, like music or dance, is a physical discipline, and the hand (as well as the mind) must be engaged.

Come join me now, palette at the ready, for this exploration into energizing your paintings with color.

— *Lewis Barrett Lehrman*

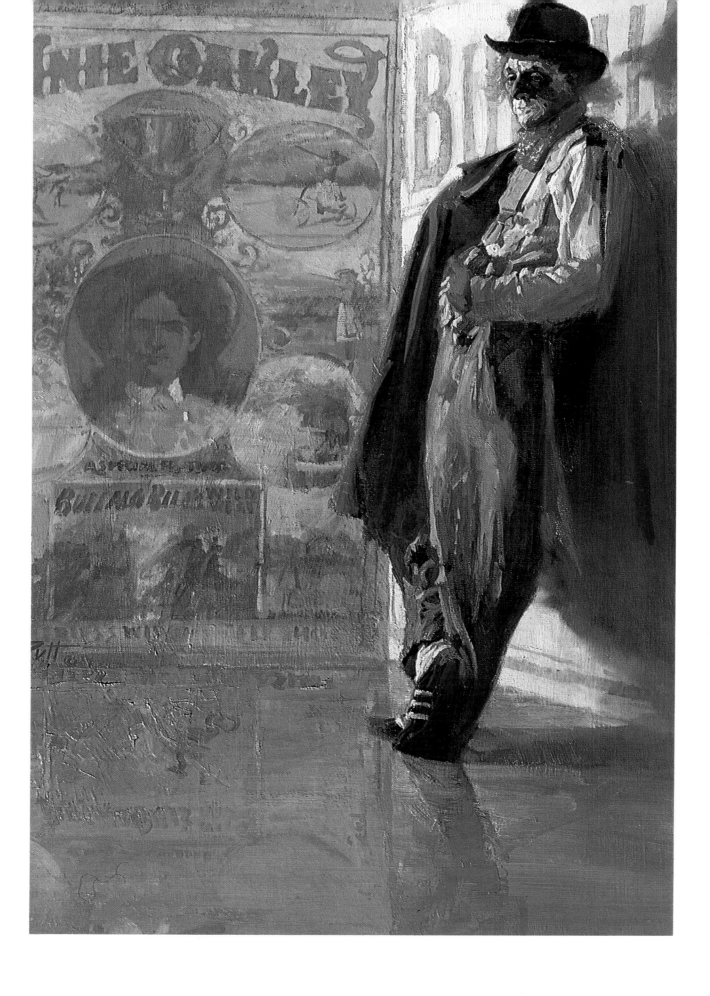

Chapter One

The Grammar of Color

Though artists have been developing, testing and practicing concepts of color harmony since the dawn of civilization, it wasn't until the nineteenth century that anyone thought to study the subject in a systematic, scientific way. Artists of the era were intrigued by the new, formalized concepts that emerged, and many were quick to adopt—and adapt—them for their own use.

Though painters had always relied upon their own observations and experiences, the Impressionists, and the post-Impressionists after them, were strongly influenced by the development of these new color theories (though it must be noted that many rebelled against *all* scientific theories of color, adhering to their own individualistic approaches).

Today, after centuries of experimentation, theorizing and study, no single concept of color has emerged that meets all needs. Nevertheless, a basic grammar of color is as indispensable for the developing artist as is the alphabet for a writer, or the chromatic scale for a composer. For that reason, if for no other, we begin this exploration of the "energizing" effects of color with a brief review of the very foundations—the grammar, if you will—of color.

Color: It all begins with light

The sunlight we perceive as white is really a mixture of wavelengths (or colors) of light. By passing light through a prism (which refracts the differing wavelengths of the colors to varying degrees) and projecting the resulting light beam on a white surface, the complete spectrum of colors in that light becomes visible.

Between red (at the lowest frequency), and violet (at the highest), you'll see, literally, all the colors of the rainbow. And though each may be thought of as unique, just three of these colors are necessary to make up every one of the others. That is why the three are known as *primary colors*.

It should be noted that since the artist deals primarily with pigments, which reflect or absorb light, we will be talking only about the primary colors of *pigments* (red, yellow and blue), rather than the primary colors of *emitted light* (red, blue and green). These primary colors of light, when combined, produce white light.

The "primary" colors, and what makes them that way

When white light strikes a surface (an apple, a face or the pigment on your canvas, for example), some of its colors are absorbed, or subtracted. They're gone. Others are reflected and reach the eye, where they are perceived as the color of that surface. When all the colors of light are absorbed, and none are reflected, we perceive that as black.

The *triadic* color theory, which is most widely followed by artists, holds that there are three "subtractive primary" colors: red, yellow and blue. They're called "subtractive" because pigments subtract out colors of light by absorbing them.

Secondary and tertiary colors

Mixing two primary colors in visually equivalent amounts produces what are known as *secondary col-ors*. Red and yellow create orange. Yellow and blue yield green. Blue and red yield violet.

When a primary color is mixed with an adjacent secondary color, a *tertiary color* is produced. This is, of course, the same as mixing unequal proportions of the two primary colors. Mixing a lot of blue with a little yellow will yield results similar to mixing equal parts of blue and green.

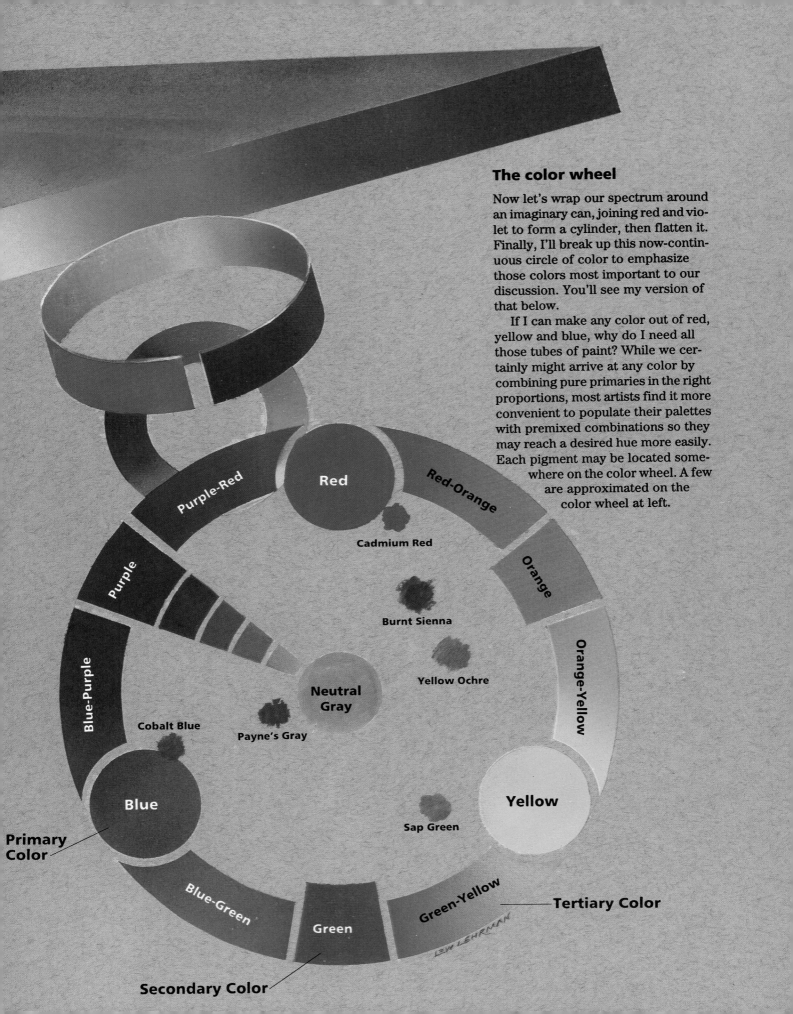

The color wheel

Now let's wrap our spectrum around an imaginary can, joining red and violet to form a cylinder, then flatten it. Finally, I'll break up this now-continuous circle of color to emphasize those colors most important to our discussion. You'll see my version of that below.

If I can make any color out of red, yellow and blue, why do I need all those tubes of paint? While we certainly might arrive at any color by combining pure primaries in the right proportions, most artists find it more convenient to populate their palettes with premixed combinations so they may reach a desired hue more easily. Each pigment may be located somewhere on the color wheel. A few are approximated on the color wheel at left.

Purple-Red

Red

Red-Orange

Cadmium Red

Orange

Purple

Burnt Sienna

Orange-Yellow

Blue-Purple

Yellow Ochre

Neutral Gray

Cobalt Blue

Payne's Gray

Primary Color

Blue

Sap Green

Yellow

Blue-Green

Green-Yellow

Tertiary Color

Green

Secondary Color

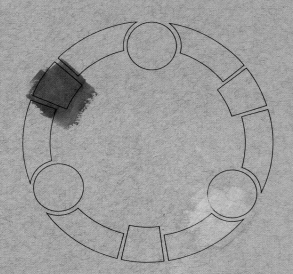

Complementary colors—color contrast

Colors that are directly opposite one another on the color wheel are known as *complements*. A primary color is always complemented by a secondary color, and vice versa. Blue, for instance, is the complement of orange. Complementary colors are as *different* as two colors can be. Put another way, they are at maximum color contrast with each other.

Combine equivalent amounts of two complementary colors and you'll get black or a neutral gray. (In reality these results are rarely perfect, since few pigments are perfect "spectrum-pure" colors.)

Warm and cool colors—color temperature

When we refer to one color as "warmer" or "cooler" than another, we are really comparing the amounts of blue in them. A cool red, for example, may contain just enough blue to shade it toward violet. A warmer red shades the other way, toward orange. What about warm and cool blues? A warm blue has more red in it; cool blues tend more toward green.

Light and dark—value

Another means of evaluating a color is by referring to its lightness or darkness: its "value." At first the concept of value may seem a bit tricky. It bears no relation to color, being simply a measure of lightness or darkness. The most intense red, for instance, has a much lower value than the brightest yellow; the strongest purple is darker than either. In color notation white is considered to have the highest value, at "10," while black has a value of "0." Think of this value range as the axle of the color wheel.

Comparing values of differing colors is much easier at reduced light level, which minimizes color contrast. That's why painting instructors encourage us to squint when composing a scene or evaluating our work.

Color intensity—chroma

Chroma is an expression of a color's brightness. The best means of reducing the intensity of a color is by adding its complement. Gradually mixing blue into orange, for example, will produce "burnt orange," then a whole range of browns, and finally a neutral gray. Some watercolorists combine burnt sienna (a low-chroma orange) and French ultramarine blue to mix their only blacks and grays.

Color harmonies

We artists use the powerful attributes of color relationships to attract, entertain—yes, even assault—the eye of the viewer. Harmony and contrast are our principal tools. In a painting, where colors are invariably seen in combination, each color is strongly influenced by those around it. A red surrounded by other reds may not seem noticeably bright. Yet, view that same red on a field of green, and its chroma will appear greatly intensified.

The following are a few basic approaches that will help guide any artist toward achieving color harmony.

Complementary color schemes

The strongest color contrasts are produced by pairing those colors farthest apart on the color wheel—the complements. Placing complements side by side in your painting can have startling results and is often the most powerful way to direct the eye to a center of interest. A painting that's full of glaring complements may not be harmonious, though you might complement a large area of low-chroma greens, for example, with a small area of intense red. To see how a tiny area of intense green in a red-hued painting immediately draws attention, see Harley Brown's *Beatriz* demonstration in chapter 11.

Analogous color schemes

Colors that lie close to each other on the color wheel are said to be *analogous*, meaning similar. Violet, red and orange, for example, are analogous colors, adjacent on the color wheel; all contain red. Choosing analogous colors for your picture is a simple, dependable way of achieving color harmony. To see an analogous color scheme at work, see Don Putman's *Waiting Maiden* demonstration in chapter 13.

Neutral color schemes

A nearly infinite variety of neutral colors may be achieved by the selective graying of colors. The entire range of browns, as I have mentioned, is based on orange. Myriad soft blues, right down to slatey grays, may be mixed from the various spectrum blues. Greens yield countless olives, mosses, and so on. The harmonies of the neutral colors are subtler, moodier than those of the high-chroma colors, and certainly warrant exploration. To see a neutral color scheme at work, turn to Peter Van Dusen's seascape demonstration, *Ahead of the Storm*, in chapter 4.

Triadic color schemes

Triadic color schemes are based upon the three primary colors—red, yellow and blue. When these colors are dominant in a painting, they establish continuity and help to unify the composition. Raleigh Kinney's beach scene demonstration, *Sunny Sunday*, in chapter 5 is based on a high-chroma triad. However, the three colors of the triad need not be high-chroma primaries. See how Peter Van Dusen put together his seascape (chapter 4) using yellow ochre, burnt sienna and French ultramarine as his triad. His selection of a low-chroma triad helps convey the stormy mood of his painting.

The bottom line: Using all this in your own work

Even the most basic understanding of how color works can help in your own development as an artist. When you're planning your next painting, draw a simple color wheel grid on a scrap of paper or canvas. Letter "R," "Y" and "B" at the twelve o'clock, four o'clock and

The Color Dynamic for *Studio Floral*

This color dynamic of the painting on the facing page suggests a strongly complementary yellow/green—violet/red color scheme, with blue broadening the color dimension and moderating the high-chroma contrast.

eight o'clock positions. Spot the dominant colors you'll be using in the appropriate areas on the grid, daubing in larger areas of the colors you'll be using more of. You'll immediately see what your complementary accent colors might be, and, undistracted by image or design, more easily develop and evaluate color harmony and balance. As well, you can always test a color before adding it to your painting by holding it against this "color dynamic" you've created, to make sure it fits into the harmonies you have planned.

A note about the demonstrations that follow

Accompanying each of the demonstration paintings on the following pages is a color diagram illustrating the *color dynamic* of the demo. Comparing each dynamic with the finished painting will show you

how the artist has used the grammar of color to achieve his or her color harmonies and contrasts. The color dynamic shown below refers to Ted Goerschner's *Studio Floral*, the painting on the facing page. Compare the two to see how the use of color energizes this artist's approach.

A final word, and then we'll get started

If you are serious with your painting, you will no doubt develop a deep and long-lasting interest in color, experiment with differing theories and approaches, and evolve your own understanding of color through your work. With all the available books, however, there is no substitute for continued working with color, pursuing understanding through experience, until your use of this powerful visual tool becomes as intuitive as your emotional response to it.

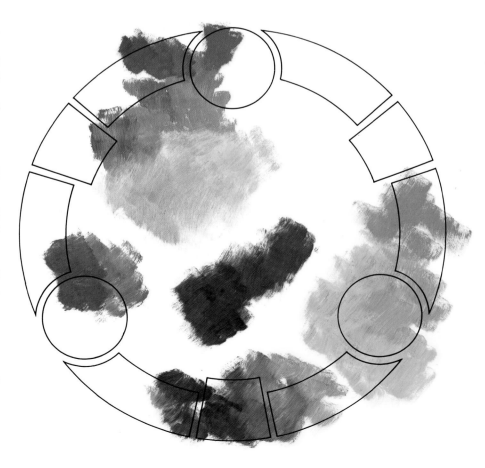

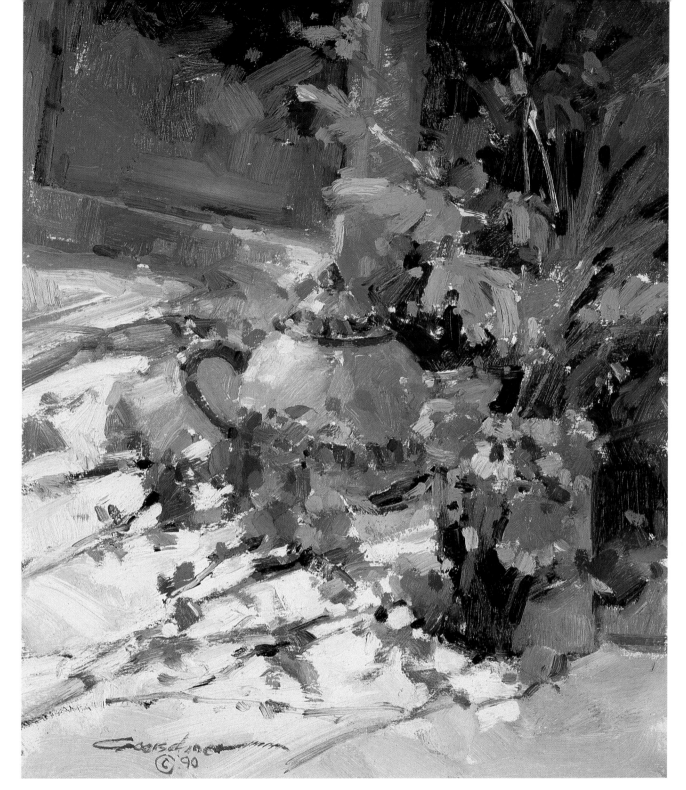

Studio Floral
Ted Goerschner
Oil on canvas
16″ × 12″

Notice the high chroma of the subject and how effectively that intensity is contrasted against the relatively neutral background hues. As Ted Goerschner puts it, "I like to push color beyond the limit of reality, creating my own combinations and making them even more colorful on the canvas."

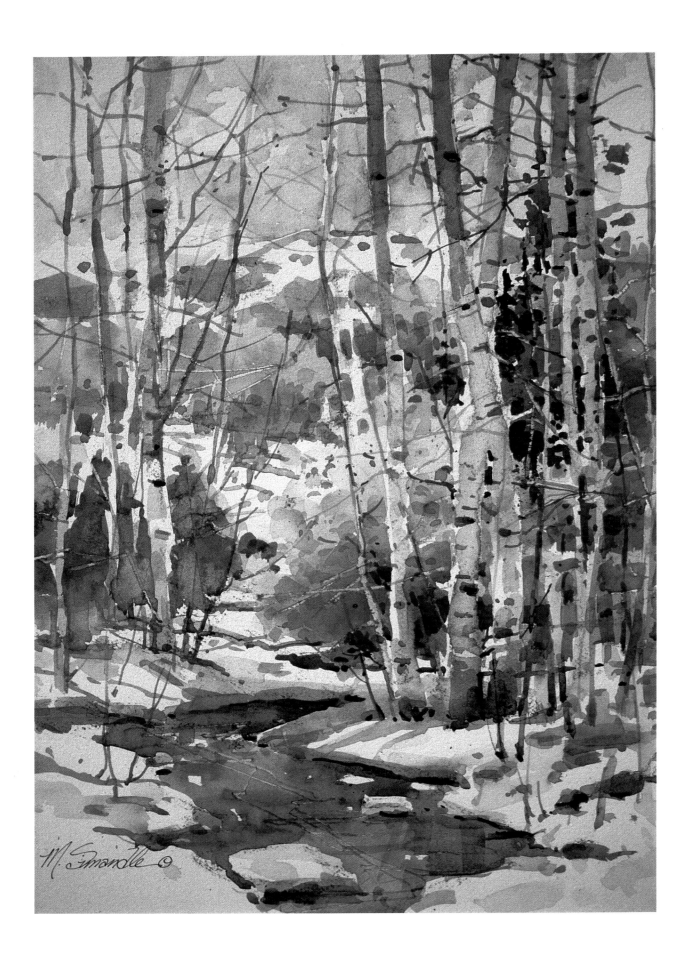

Chapter Two
Using Color to Create Excitement

Marilyn Simandle paints Portuguese fishing boats

No medium surpasses watercolor in its ability to capture the spontaneous excitement of color and light. The very liquidity and unpredictability of the medium call for a free and loose approach. Control watercolor too tightly and much of its appeal is lost. No wonder the phrase "happy accident" is used in discussing watercolor and no other medium.

California artist Marilyn Simandle's watercolors have always personified, for me, the essence of energized color. Her paintings, radiant with light, look like they might have fallen effortlessly onto the paper, with every splash and splatter in precisely the right place.

In the real world, however, the successful artist relies more on "planned spontaneity" (as Degas called the careful approach that enabled him to produce his loose and vibrant works) than on accidents, happy or otherwise.

I felt certain Marilyn would be no exception to that method of working, and immediately contacted her when I began planning this excursion in color. Her painting session was every bit as exciting and informative as I'd hoped it would be. Now share the experience as Marilyn Simandle paints *Lagos Light* for you.

The artist began with thumbnail sketches of the scene, based on photos she had taken during a recent painting trip to Portugal with Plein-Air Painters of America.

1

Getting started

Having worked out her basic composition in miniature, Marilyn redraws it on a stretched sheet of Arches 140-lb. cold-press watercolor paper.

M.S. — Portuguese boats are probably more colorful than any other boats in the world. This scene is from Lagos; the photos are from the whole mess of pictures I took.

L.L. — Is much of your painting done from photos?

M.S. — When we travel, I take a backpack with watercolor blocks, easel, palette, and carry a camera around my neck. I look like a Martian that just got dropped off! I'll do quick paintings — 9″ × 12″ up to about 12″ × 16″ — spending about a half hour on each. And I take lots of photos. Back in the studio, I work from those paintings and photos.

Marilyn puts finishing touches on her pencil sketch.

M.S. — Watercolor is not quite as forgiving as oil, so I've got to have a good game plan, to know where my lights and my whites are going to be.

Shadow shapes, values and colors are also very important. Without shadows you won't feel the light. How you handle the shadows makes a painting feel like there's light in it.

I'm not thinking of color now, just about placement, though I know that most of my bright colors are going to be in the center of interest. I am thinking of value though. The middle ground will be all in shadow, with light coming in from back right, shadows going left.

They call it "Simandle gray"

Marilyn prepares her palette, squeezing out fresh Winsor & Newton pigments.

M.S. — It's important not to have too many colors on your palette. Right now I use cadmium yellow and orange, scarlet vermilion, raw and burnt sienna, alizarin crimson, permanent rose, French ultramarine, cobalt, manganese and Antwerp blues, and viridian green — sometimes sap green. I'm always experimenting, phasing colors in and out. It's a very personal thing.

She begins mixing a grayed wash in her palette.

M.S. — This is a triad of permanent rose, manganese blue and raw sienna. My students call it "Simandle gray." Everything will grow out of these colors.

Beginning just above center, she lays in her gray, using a no. 10 round sable. Her board is nearly vertical on the easel, and she grasps her brush loosely, back near the end, controlling the amount of paint to avoid runs. Extending the shadow mass downward and to the right, she continues varying its color, delighting in the bleed-backs and dry-ups that occur.

M.S. — I change the wash as I go along: warmer, cooler, lighter, darker. That's the basis of my harmonies. I'm always thinking of negative shapes too. They're as important as the shapes I'm painting.

With a palette knife, Marilyn lifts pure raw sienna from her palette, smearing it into the shadow mass.

M.S. — I look to create lost edges and broken edges. Notice where the mast will cross the wall area? That's a broken edge. Lost and found edges are important. If you don't have them, your eye gets

2

3

trapped within an area. You always have to think about eye movement.

She uses her palette knife to scrape out ropes against the shadows. A light-blue wash forms background buildings at left. Raw and burnt siennas are used for rooftops.

M.S. — I want my painting to be really loose, except in the center of interest, where I want all my detail, all my color.

The foreground

M.S. — While I've got grays in mind, I'll go right into the shadows on the boats, using the same three colors.

She lays shadows in, then drops raw sienna into the still-wet areas.

M.S. — Colors are the connecting elements in your painting, giving it unity, harmony, excitement. Repeating colors throughout the painting helps the eye move around it easily.

She adds mooring lines in the foreground, spatters a few spots at right.

M.S. — I want to save most of my detail for later, so I'll go on to my next biggest shapes — the trees in the background.

4

Building the background

Marilyn begins laying in greens.

M.S. — You really don't even need green on your palette. You can mix so many greens from the colors you have. Cadmium orange and viridian here; burnt sienna and viridian for dark green. The fewer colors you mix, the cleaner your painting will look.

She grays her green with permanent rose, carrying the tree mass toward the corner of the painting. A lighter green is scrubbed in at left. Branches are scraped out with a palette knife. Others are flicked in with the rigger brush.

M.S. — I try not to fall in love with any one area and attempt to finish it. I want to develop all parts of the painting at the same time.

Developing color energies

M.S. — This part of the painting is the most fun because it's when I put in the bright colors that'll bring it to life.

Squinting to judge values, she lays in orange, waits for it to dry completely, then glazes cadmium yellow over it. With a fine brush, she dots in details around the boat at left, then works on the one at right.

M.S. — I really don't try to make everything look like something. I get the essence down, the basic shape — not "things" — shapes and values.

Dark accents are added to the keels of the boats.

M.S. — Deep values change everything in the painting immediately.

Using her palette knife, she breaks up edges where she has just laid down color.

A little cadmium orange

5

warms the shadowed side of the foreground boat. Lines are scraped into the shadow while it is still quite wet, and paint flows into the lines, turning them dark. Using her rigger, she paints fine lines and boat details.

M.S. — One of the problems many watercolorists have is they try to control everything. Then when they lose control somewhere, like a waterspot or something, it looks terrible. I just let it happen.

Getting down to details

M.S. — "Start out with a broom, end up with a needle." I forget who said that, but they were right.

Concentrating on the boats now, Marilyn reglazes some areas to deepen them, scrapes out lines, and adds more dark accents while paying particular attention to the negative shape of the white against the building. With a fine brush, she details hanging nets and other paraphernalia — all by painting their negative shapes. Then she extends that darker value up and outward, working carefully and precisely — planned spontaneity at work!

M.S. — I mix Antwerp blue and burnt sienna for my darkest darks. It's the dark values that will make my colors pop.

The turquoise from the boat finds its way into the foliage and shadows. Raw sienna from the middle ground is carried upward, to the roofs, and downward into the boats and sand.

M.S. – I like to make my colors travel through the painting, like melody through a song.

Cadmium orange and a touch of permanent rose make a warm wash that's brushed into the foreground to tone down some of the white on the beach.

M.S. – I have no doubt where I want your eye to go. The center of interest is where I'll have my brightest colors. If they're all over the painting, you won't know where to rest your eye.

See the escape route here in the middle of the three boats? The connected white areas give your eye a way out. Same in the left background, where the shapes of the houses are all connected. Don't lock up your shapes by totally enclosing them.

Just enough detail

M.S. – Remember that you don't want a perfect painting. There's nothing more boring than a painting in which everything is spelled out. It's like one person dominating the conversation. You always want the viewer to participate.

Marilyn details shapes in and around the boats, strengthening their shadows.

M.S. – If I'm not sure how big I want a shadow area to be, I'll just put down a dot and expand it until it gets as big as I want it. Then I'll stop.

She switches to a larger brush and washes light manganese blue into the sky.

M.S. – Doing skies, you can totally use your imagination, because at one time or another, the sky has

6

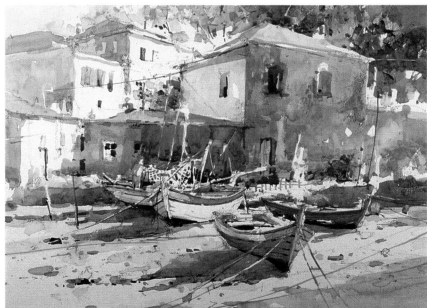

7

appeared any way you can imagine it.

A cooler blue wash is brushed into the right foreground and glazed over other areas.

M.S. – The foreground is just a way to get you into the painting. The background is there to get the center of interest to stand out. Har-

mony with diversity: Harmony is sameness and diversity is difference. Harmony usually implies an analogous color theme and closely related values. Diversity means complementary colors and strong value contrasts. You want your painting to be a combination of both harmony and diversity.

Adjusting values

M.S. — Right now I want to bring out the center of interest more. Watch how stronger values around the boats will bring them forward.

Moving toward the right, the artist builds darker texture along the base of the building. Deeper greens are brushed into the tree masses, and a new tree appears between the buildings at left center.

M.S. — I feel the painting needs a dark mass at right, so I'll add another boat. And that gives me a good excuse for a shadow.

Dark values are dotted into the foreground. Light washes of sienna, pale green and so forth, close out some of the remaining white "holidays," or dry spots where the brush has skipped over the paper. Compare this picture with the previous stage, and see how the center of interest has been brought out.

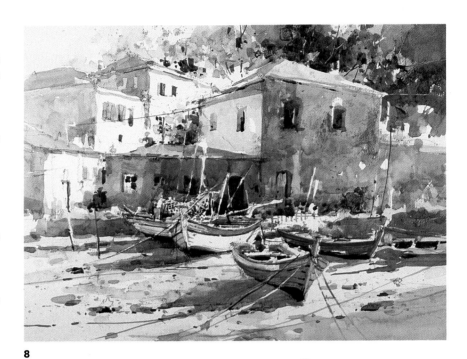

8

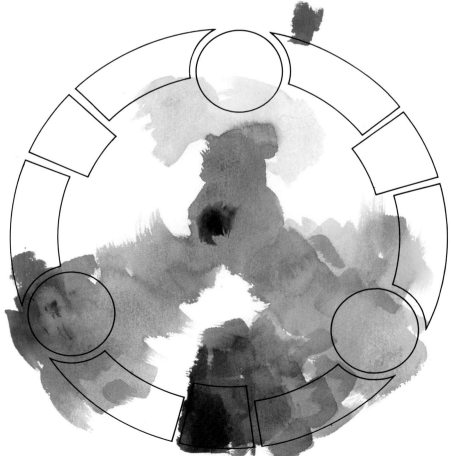

The Color Dynamic for *Lagos Light*

Analogous colors that run from yellow to blue, accented with bright reds and subtle mauves.

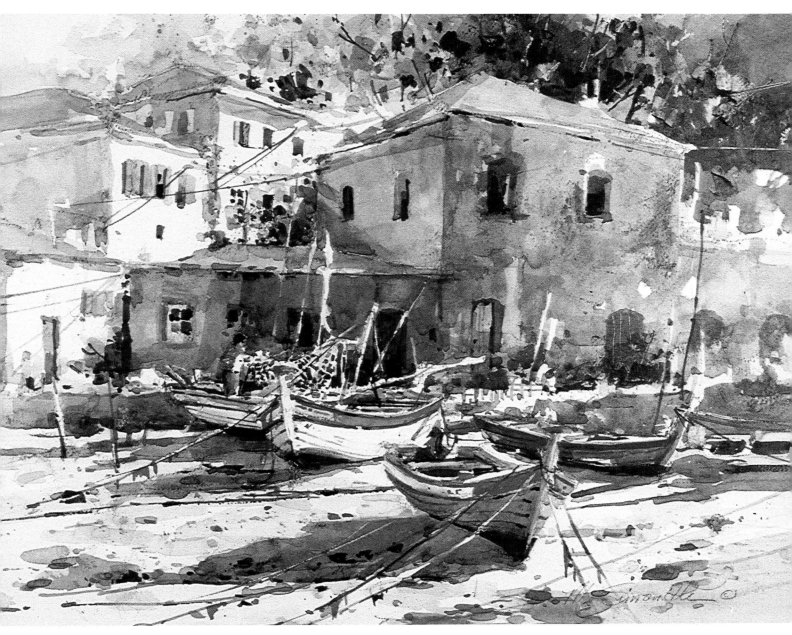

Lagos Light
Marilyn Simandle
Watercolor
17" × 22"

The finish

In finishing her painting, Marilyn has enriched some of the shadow washes with glazes of color, added some foreground detail (like strands of seaweed on the lines), deepened some shadows, and straightened a few lines, all while carefully avoiding over-defining her subject. Several hours of concentrated effort have succeeded in making *Lagos Light* look like it just happened!

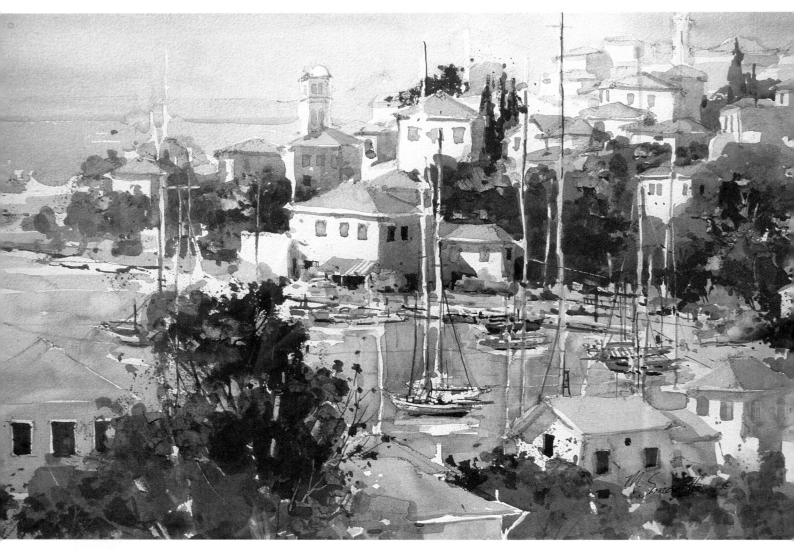

Greek Isle
Marilyn Simandle
Watercolor
16" × 24"
Collection of
Marjorie Hall

In her light and airy painting of this sun-drenched Greek fishing village, Marilyn Simandle invites you to wander and explore, much as you might stroll along its meandering byways were you really there. Follow the progression of rooftops from foreground to background, the verticals of repetitive masts, colorful boats, deep green trees, and windows, and you'll eventually come to rest at the harbor. You can almost taste the ouzo.

Note how the lighter value areas in this painting are always interconnected, serving as pathways for visual exploration. Though the deep green of the foliage defines the darkest values in this painting, the eye never feels trapped within enclosed areas.

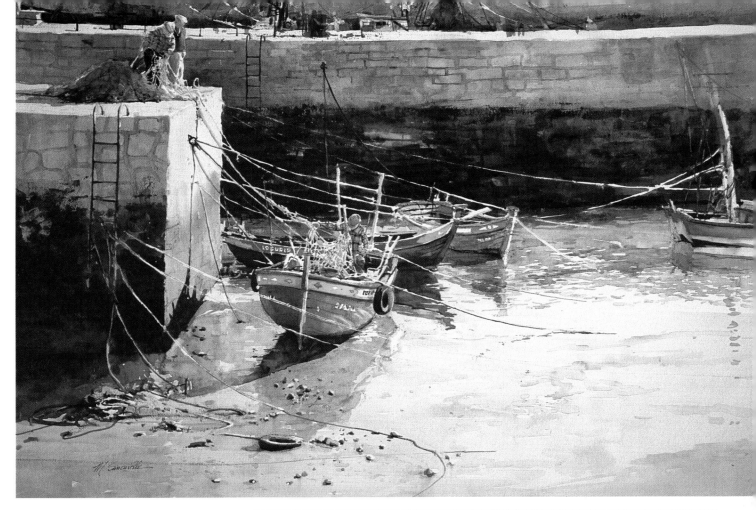

Network
Marilyn Simandle
Watercolor
24″ × 36″

A studio painting that was done from photos taken in Portugal, *Network* illustrates how important "empty" space can be in a painting. When your eye has taken in the colorful confusion of boats and lines, nets and reflections, it will find rest in the calmness of the water or the darkness of the mossy, tide-marked pier.

It's no accident that the principal boat is painted in violet. The artist wanted maximum color contrast against the dominant yellow of the painting and enhanced the effect with brilliant orange along its gunwales. You'll also find the boat's violet subtly repeated elsewhere in the composition.

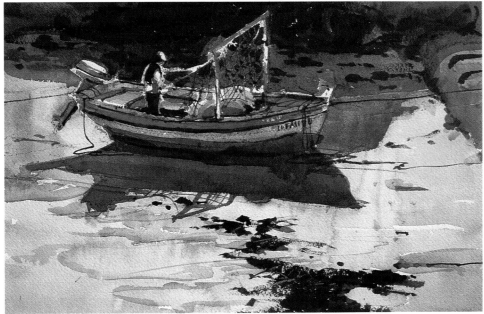

Portuguese Fisherman
Marilyn Simandle
Watercolor
12″ × 16″

An elegant little painting that's built around a triad of cadmium red, raw sienna and manganese blue. Painted on location in Lagos, Portugal at 6:30 one morning, its colors glow against a neutral background created out of those same colors. White accents in the boat and fisherman add their own brilliant sparkle to the work.

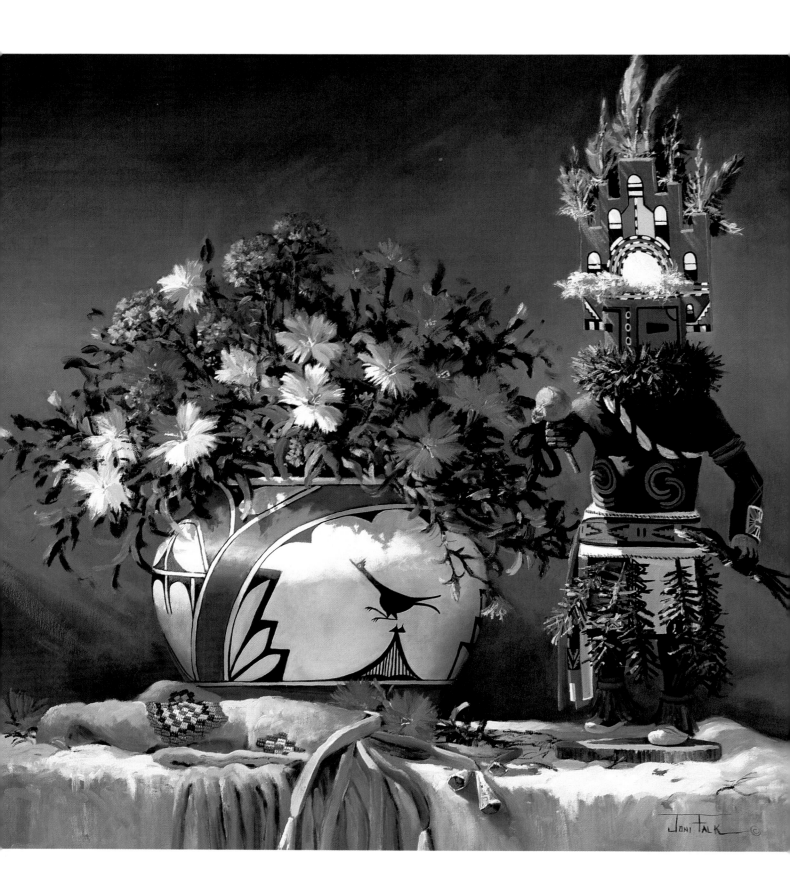

Chapter Three

Color Energy With a Limited Palette

Southwest Expressions
Joni Falk
Oil on canvas
36" × 36"

Though a cool, dark background helps to intensify the colors, it is brilliant red, repeated in flowers and kachina doll, that unify this composition. The color dynamic of this painting may surprise you: Cool red, violet and blue dominate. The rest are accent colors, with yellow the strongest color—and value—contrast.

Joni Falk paints a still life

Many artists, overwhelmed by the complexities of painting, adopt a "back-to-basics" approach, sidestepping as many problems as possible in order to concentrate on essentials. One way they might accomplish this is by eliminating color entirely, factoring out the endless decisions involved in dealing with hue and intensity. Some artists go so far as to work with just a single color for months—even years—before adding even a second color to their palette, building quite slowly, a step at a time, to a fully chromatic palette. Though this measured process may not be for every artist, it is a well-proven, time-honored path to becoming comfortable with the complexities of color. If this approach seems appealing, why not try it—even for just a single outing? At the very least, it can offer a creative means of approaching a most complex subject.

In a very real way, the demonstration in this chapter, Joni Falk's *Lavender and Blue*, illustrates this process at work. Beginning with a purely single-color delineation of the subject, Joni builds her painting through the gradual addition of color, arriving at a finished work, which, while still limited in palette, is fully realized in every way.

1

The palette

Joni normally sets out a fairly full palette. "I may not use all these colors," she says, "but I like to have them available." She mixes a variety of grays, to be used for warm and cool variations. A variety of purples is also prepared, as are several greens, all keyed to colors she sees in her subject. A small pan holds Winsor & Newton's Liquin. It is her favorite medium because it gets tacky quickly, which allows her to lay color on color and to blend tones without lifting the base layer.

Initial lay-in of color

To start with, Joni coats her canvas with an olive green/burnt sienna wash, thinned with Turpenoid. While the paint is still wet, she dips her brush in the solvent and lifts out areas where lighter flower petals will be. As she wipes out the flower petals, she also begins to rough in some of the shadowed areas, using the same colors. The composition begins to emerge.

J.F. — In a sense this serves as my original thumbnail sketch. I don't always start with a toned canvas, but I find that things come together much faster when I do because I'm immediately able to start working with lights as well as darks, and I don't have to keep adjusting my values. This monochromatic "sketch" enables me to concentrate on values and composition without concern for color at this early stage.

Compositionally, I'll focus on the two large poppies as my center of interest. There will be whites for a crisp look, establishing my lightest values, and little highlights of yellow, the complement of violet, for color contrast and sparkle.

2

Blossoming out

Plunging right in, Joni tones both poppies dark violet, the paint layer kept as thin as possible to keep it workable. Then, coming back over each petal, she blends in lighter shades of her premixed violet. A touch of green is added at the center of each blossom. Gradually, she builds up the pattern of lights and darks she sees in each petal, brushing in a variety of violets—some warmer, some cooler—to maintain visual interest.

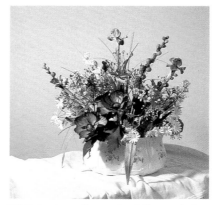

While Joni usually uses fresh flowers in her arrangements, she has selected this arrangement of dried and silk flowers for its ability to last the extended time of the demo.

Defining the value range

Mixing indigo with Indian yellow, Joni begins scrubbing in dark leaf masses around the poppies, establishing the darkest values that will appear in the painting.

With these darks in place, she moistens her brush with Turpenoid and begins lifting out some of the daisy petals that will later be brushed in with white.

J.F. — I tend to "sneak up" on some of these flowers, just suggesting them at this point to see how I like the effect.

Using white, with just a touch of ochre, Joni begins brushing in the foreground daisies, noting that these will be a warmer white than the bowl.

J.F. — I've learned to limit the greatest contrast to about a third of the surface, allowing the rest of the painting to lead up to it. That one-third can be a horizontal or vertical pattern that moves through the painting.

Establishing the color dynamic

The flower bowl, which will be the largest mass and the lightest value in the painting, is now brushed in with shades of white and warm gray.

J.F. — I like to allow the underpainting to show through at this stage, regardless of whether it will end up that way at some later stage.

The right side of the bowl becomes a bit cooler, as its edge becomes lost in the dark tone that she now adds as the shadow. Yellow-green is added and blended with the shadow tone, and the background is extended upward and around.

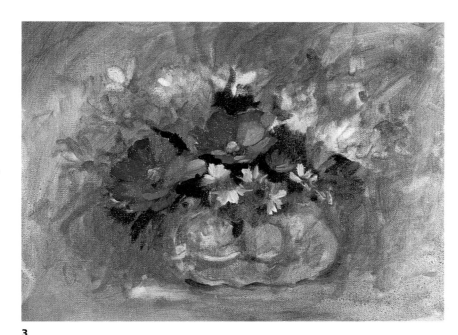

3

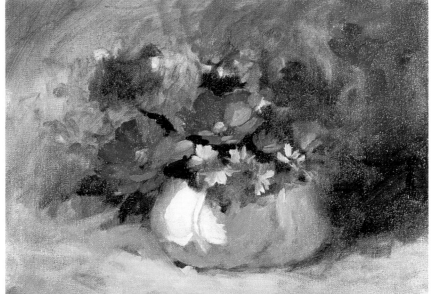

4

Dark red-violet is now scrubbed in to form the two flower masses at top left and top right center, and blue-violet is added for the four smaller blossoms.

Defining flowers

Working across the painting, Joni begins to define individual blossoms, extending the composition upward and out. The cluster of violets at right center is roughed in, then the irises at top right and center.

J.F. — I prefer to work on shadow areas first, coming back with the lights. This way I can easily manipulate the full range of values.

I see the bright light striking the picture at the highlight on the bowl, moving upward through the poppies, curving right, then left to the background at top. By softening values at left and right, this vertical emphasis will become even more important as the painting progresses.

Purplish-grayed whites are used to lay in the flowers at right, and more shadow-toned petals are added to the daisies at center. Highlight-white brushstrokes bring some of these petals forward to create the brightly lit daisy at left.

Bringing it up

With basic flower shapes established, Joni adds dark green values between the masses, working all over the canvas. Scrubbing in leaves and greenery, she establishes a rhythm of dark masses that travels horizontally across the canvas.

Continuing outward, Joni adds the lighter-toned flower at top left. Then standing back from the painting, she decides that the poppy petal values need rethinking. The artist reevaluates and adjusts the values in each area in relation to those just developed around it.

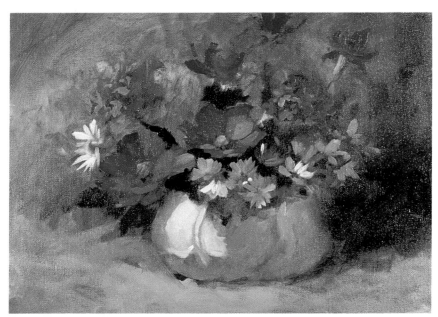

5

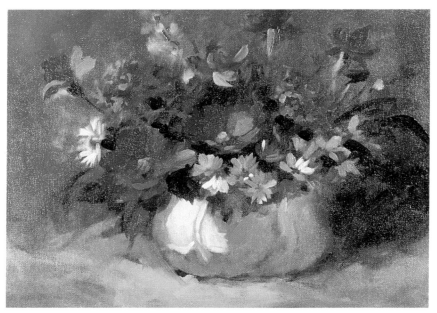

6

Dealing with the background

Before detailing any more of the foliage around the perimeter of the arrangement, Joni turns her attention to the background.

A soft, grayed, dark violet is first scrubbed in at top left. Blended with a midrange grayish green, it becomes lighter as it widens out in both directions. Joni scrubs her background right into the already-painted flower masses, causing some to disappear entirely. (They'll be recovered later.)

The area that is to become the iris at top left is lifted out of the background with Turpenoid on a brush, then brushed in with dark purple values. Lighter shades of the violet are added and blended over these.

J.F. – I'm trying not to follow the arrangement religiously. I don't want an exact replica. I want the viewer to participate and finish parts of the painting along with me.

With the background brushed in, Joni rebuilds the smaller flowers around the perimeter. Then she turns her attention to the varied greens of the leaves and to the highlighted and shadowed daisy petals.

Highlights add dimension and sparkle

Joni makes further adjustments in the values and color of all the purple blossoms. Before beginning on the tiny yellow flowers, she brushes soft, feathery strokes in a range of light greens into the darkest green shadow areas, suggesting a network of fine stems and leaves.

J.F. – Because the poppies and iris are so large and bold, the tiny wildflowers will add a nice contrast

7

8

in both size and color. I'll add them gradually, judging the effect as I go.

As she paints the yellow flowers, she also continually goes back to other areas to spot in white, pale violet and yellow-green highlights, adding bright sparkle across the surface.

Heading for the finish

J.F. — I've spent some more time on the background, intensifying and warming it at top left and darkening much of the rest of it. I have developed some of the flower shapes too, especially those that show against the background.

The painting, I noticed, was predominantly cool colored, so for a warmer feeling, I warmed many of the whites and the background.

The process of highlighting and adding contrast to the surface with small points of white, yellow and violet has also been continued and is beginning to create a bright outer "shell" of highlights that sparkle against the inner, shaded core values.

Joni begins to detail the bowl, being careful that it doesn't distract from the floral arrangement.

The cloth is also more fully modeled now — brightest where it is struck by reflected light from the white bowl, disappearing against the background in shadowed areas.

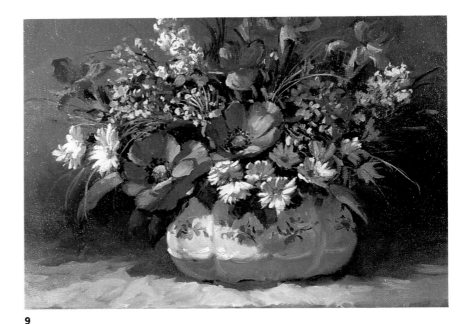

9

The Color Dynamic for *Lavender and Blue*

The artist has played her monochromatic scheme against yellow-based complementaries. Greens and blues soften the color contrasts.

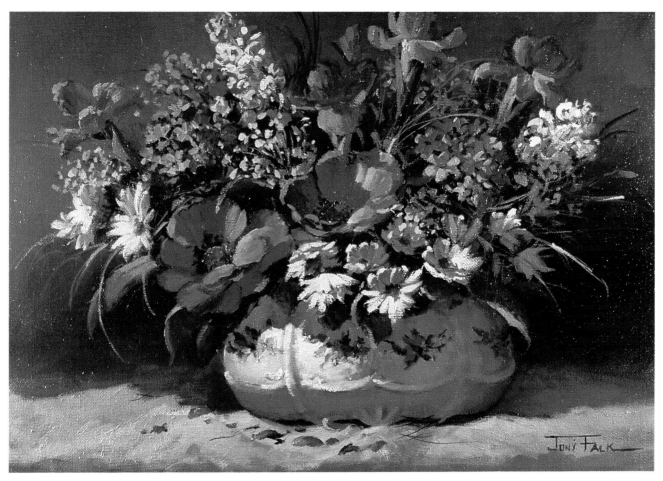

Lavender and Blue
Joni Falk
Oil
12" × 16"

The finished painting

In finishing the painting, Joni has adjusted the tablecloth to a cooler hue while highlighting the bowl by making it warmer. Warm, pink reflected light glows in the shadows on the right half of the bowl, preventing it from disappearing into the foliage or the background.

Fallen petals have been placed on the cloth to break up its smooth expanse. They stop the eye, moving the viewer's attention to the highlights of the bowl, then upward, as the artist intends.

Color intensity has been increased on some of the irises, and a few more groupings of yellow flowers have been added, properly subdued with yellow ochre to keep them out of the highlighted value range and to round out the arrangement. A few bright yellow-green leaves at far right and left catch the light, coming forward strongly against the dark background shadows.

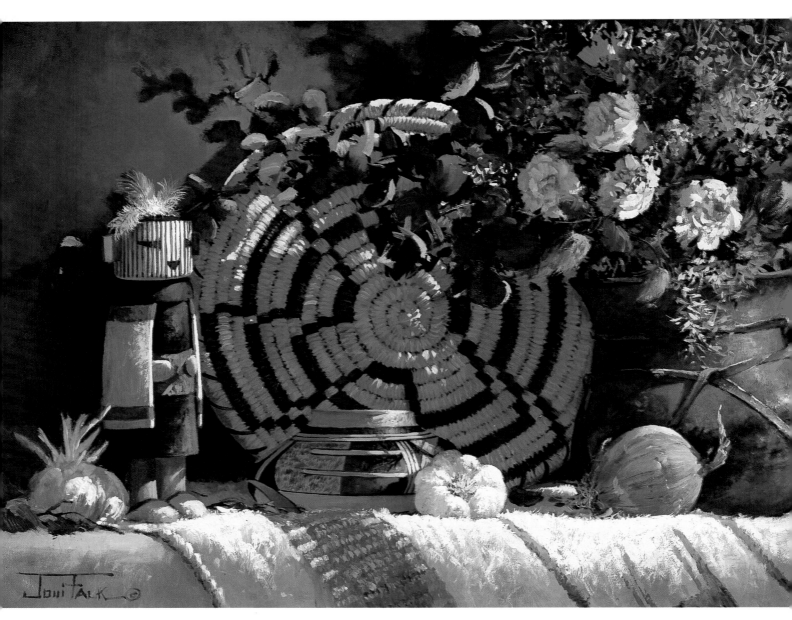

Hopi Treasures
Joni Falk
Oil on canvas
12" × 16"

The brilliance of color in the kachina doll breaks it free from the restrictive confines of the limited palette employed every- where else in the painting, bringing this composition to life.

The Taramara pot at right, with its wonderful patina, is contrasted against the yellow of the onion as a secondary center of interest.

Textural contrasts are also employed to advantage in *Hopi Treasures*, as tex- tures of blanket, flowers, basket and ka- china are expertly played against the smoothness of the onion and pot.

Petals and Clay
Joni Falk
Oil on canvas
5" × 7"

The simplicity, directness and power of
this painting belie its diminutive size,
proving that miniature paintings need be
no less effective than their larger counter-
parts. Strong contrasts in size, shape,
value, texture and color are the keys. No-
tice particularly how the smoothness of
both background and pot contrasts with
the rough-edged, brightly illuminated,
high-value, high-chroma flowers. There
can be no doubt about the center of inter-
est in this painting.

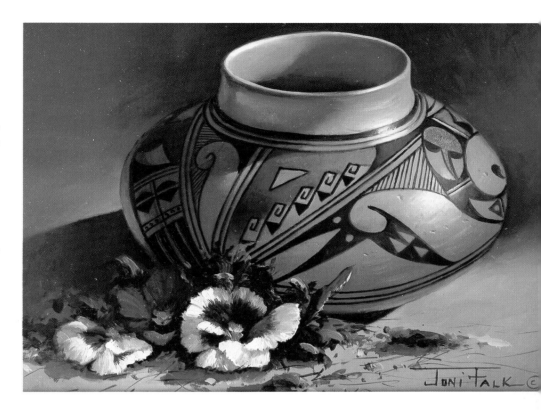

Summer Radiance
Joni Falk
Oil on canvas
36" × 36"

This arrangement of Gerber daisies ap-
pears to include every color in the rain-
bow. In reality, it is an analogous color
composition in intense, warm tones, with
violet and blue color contrasts. A strong
vertical is formed by the fallen daisy and
the folds of the cloth at bottom, moving
upward to the pink daisy at top. The
viewer's eye, entering at the yellow daisy
on the left, follows the increasingly red
blossoms to the same pink daisy, and to
the repeated pattern of the daisies at
right. White and violet blossoms further
involve the eye in a circular movement
through the painting. The brass bowl and
dark bronze background echo the golden
daisy, confirming the warm character of
the composition.

Chapter Four

Capture the Spirit of Nature With Color

Peter Van Dusen paints a seascape

To those of us who have grown up near the sea, the power and majesty of the ocean in all its varied moods can never be forgotten. Stories of the sea have captured the imagination since well before Homer's *Odyssey*. To this day, the writer—and the artist—who can summon up its awesome power are assured an eager and receptive audience.

Peter Van Dusen is no stranger to the sea. Though now retired from a long career in earth science and natural resource management, he and his family lived for many years along the coast of Maine, attuned to the ever-changing moods of the mighty Atlantic. Today he lives and paints in the desert Southwest, but the lure of the sea still finds occasional expression in his art.

Getting started

Arriving at my studio for this demonstration painting, Peter Van Dusen carries a small pencil-and-oil-paint study he has prepared. As he gets ready to work, I ask him, "What do you think is the secret of a good seascape painting?"

P.V. — Keep it simple. Artists tend to put in too much stuff: sea gulls, cliffs, mountains, ships. With all that complexity, it's hard to create a mood.

I often work from photographs, but I prefer to do a painting like this from memory. I usually start with some sort of value sketch, often a sketch in oils on plain paper — they dry so quickly. I begin by concentrating on abstract shapes, getting a feel for dominant colors, letting that tell me how to lay out my palette. For this painting I'll work out of an earth-tone triad.

The palette

Peter squeezes out burnt sienna, yellow ochre and ultramarine blue in a triangular pattern, dragging the pigments out with his palette knife until pairs of color meet. At each meeting place, he blends in some white, developing a range of lighter values.

P.V. — The idea is to keep my palette as clean and organized as I can.

Warm grays and cool grays will come out of the sienna-ultramarine mix. My water tones will be based on permanent green light, ochre and ivory black (at left on the palette). I'll keep cerulean handy for blue variations.

Laying in color

Having already sketched his composition on the canvas with yellow ochre, Peter is ready to begin laying in color.

P.V. — I'll get my darks in first to give me a feeling for the density of the painting. I don't like to do backgrounds first. I like to get right into my subject. That gets me excited about it right from the beginning.

Peter starts with the dark green wave mass at left, thinning his paint with a bit of Turpenoid. His brush is a quarter-inch sable flat.

P.V. — I love to start out with this almost colorlessness — very dark, almost muddy. On these beautiful

big foamy areas, I'll go deeper to create contrast, then brighten it as I go along.

He roughs in the skyline and adds dark notes along the bottom of the breaker. Then, adding yellow ochre to the green, he lightens values along the crest. He shifts to burnt sienna/ultramarine grays, adding these to the waves at center and right. Alternating between green mix and gray mix, he establishes a pat-

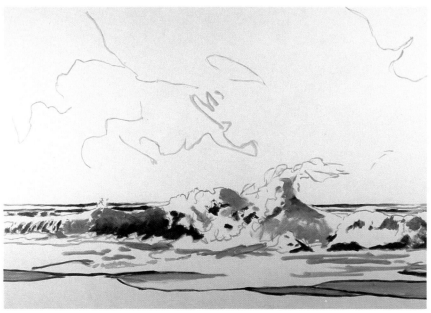

1

tern horizontally across the picture.

P.V. — I want to establish my forms first. The gray portions are reflecting light from behind. Wherever there's lots of air in the water with light coming through, you'll see green. The eddies that spread out on the beach reflect sky color.

Storm clouds on the way

P.V. — I'll start to build the background now. I've added cadmium orange to my palette, as a softer complement for the blue, stretching it out to make a warm, soft gray.

Peter begins along the horizon with neutral tones.

P.V. — I really enjoy this part of it, creating a whole series of variations. I'll keep varying the blues, using both cerulean and ultramarine . . . ochre to warm them up. The idea is to maintain a kind of "parent" color in every combination (that'll be the ultramarine), which will help pull the whole sky together.

A dark streak becomes a cloud deck, and Peter paints lighter below it, warmer and lighter above.

P.V. — Sometimes you can get carried away with storminess and come up with a painting that's impossibly dark, dull and ultimately uninteresting!

He tests dark gray above the breaker, adjusts it, brushes it in to contrast with the white foam, carrying the color left and making it lighter and warmer as it approaches the left edge.

P.V. — With my light coming in from the left, I'll move toward cerulean and ochre on that side, more ultramarine on the right.

L.L. — Is there a design to your clouds?

P.V. — Not really. I don't want them to be too complex, too defined. . . .

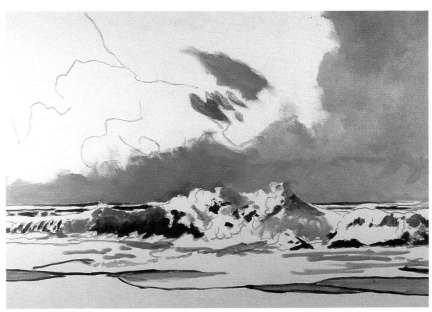

2

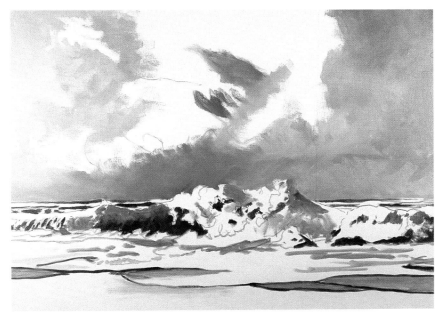

3

Building up cloud forms

Turning his attention to the top left, Peter mixes burnt sienna and ochre, laying in the warmest part of the cloud. He cools the ochre with gray mix, extending the cloud area up and to the left.

Switching to a half-inch sable, he brushes in the cloud to the right of the ochre passage and

continues to brush in grays, varying warm and cool as he goes, his brushstrokes moving in all directions, defining no edges. He works downward to the horizon, then upward to the top of the canvas. Yellow ochre and just a touch of burnt sienna are brushed into the clouds just right of center. Warmer grays connect the cloud masses.

Completing the sky

Gradually, Peter closes out the unpainted sky areas. Cerulean warms the clouds at left, suggesting blue sky showing through. A white-ochre mix lightens other areas. Slanting strokes close to the horizon suggest falling rain, incidentally moving one's eye toward the wave.

P.V. — I build my clouds by overlaying color. The more I can do that, the prettier they get. But I have to keep my colors closely related, or they'll get "circusy." That's why I like the softer earth tones. They're easier to handle. Look at the lovely violet I get from the sienna and blue.

L.L. — Is there a secret to painting cloud forms?

P.V. — I'd say, paint light against dark, warm against cool. Be aware of where your light is coming from. Cooler, darker colors look like the shaded back of a cloud. Warmer, lighter colors suggest the side facing the light.

He brushes lightened ochre into the sky near the center, blends that into the area around it, then moves this upward, creating a subtle vertical band.

P.V. — All those horizontals at the bottom bother me. I want to break that up. So I'm creating an S-shaped vertical element, from top center, downward toward the wave.

See how the light is coming in behind the cloud at the left? I want to build another cloud mass at top left center to fit with that. The clouds have to become cooler as they move to the right, almost reddish at right center, more greenish along the horizon, because of atmospheric haze.

He softens the line of the cloud deck, then pulls some more rain streamers downward at center.

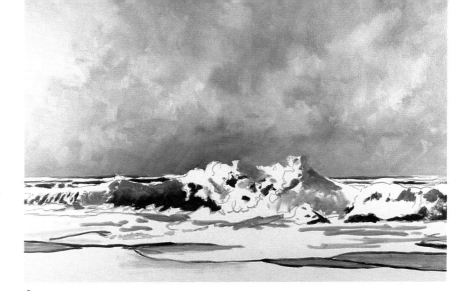

4

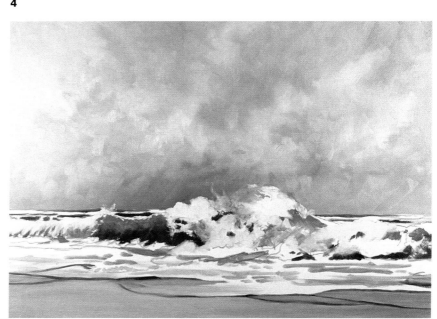

5

Building the foreground

P.V. — By now I've established my brightest whites, my darkest darks and my middle tones. I'll try to maintain that bright foaminess right to the end.

He brushes in foreground color, echoing sky tones at left, blending them with ochres toward the right. He darkens in the reflecting eddies.

P.V. — The left side of the beach will be a little lighter to help the eye see the light source.

Ochre tones are brushed into the foam at center foreground. He begins to work into the main wave.

P.V. — I can use all my colors here. I'll build my greens out of ultramarine/ochre, a little cooler than the permanent green/black I used before.

He brushes an ochre-tinged white into the edge where foam meets sky, then blends it with his thumb. The body of the wave is painted with neutral grays.

P.V. — I have to lay in those soft tones first, otherwise the lights won't look light at all. It looks confusing now and the only way to pull the area together is to blend the shapes and values right now while everything is still wet. Someplace here I want to have a great, delicate passage, with foam flying.

He adds a delicate curl at the crest of the main wave, and the foam just breaks the horizon; he approves of the soft transition.

P.V. – Aah! That's what I'm looking for!

Defining the center of interest

P.V. – To create more interest at the center, I want to sculpt the shapes of these waves now.

Using his storm-cloud gray, he lowers the white foam between the two wave crests until the distant horizon can be seen between them, adjusting the wave forms until the differences satisfy him.

P.V. – Instead of a single element, I now have a primary *and* a secondary center of interest. Now I've got to start pushing colors. I can't be timid here.

He brushes blue into the wave at right, then adds brighter green to the breaking wave where light comes through it. Taking up his small sable round, he works along the distant waves, adjusting color, alternating bands of blue/green and foamy white, keeping the value contrast strongest where color meets foreground foam.

Beachfront development

Turning his attention to the foreground, Peter picks up a broader sable flat, softening the foamy areas at the base of the breaker and to its left and right. The foam becomes more interesting and takes on more dimension as blues and greens are added.

P.V. – Where the breaker curls over, you'll see wonderful circular swirls that define its shape: dark bits of matter caught in the water, lighter hints of foam on its surface. Closer to the top of the curl, I'll

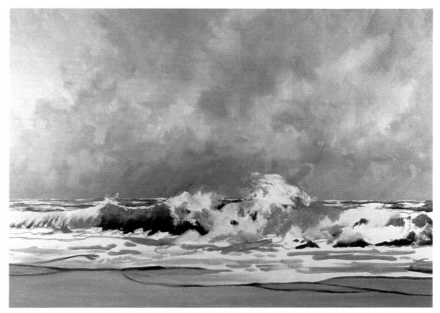

6

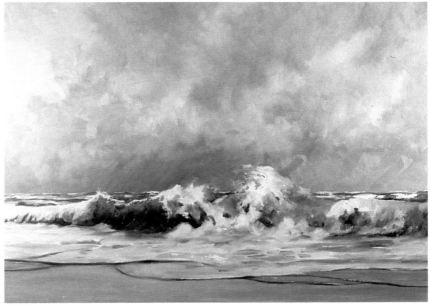

7

warm up the tone with yellow ochre. I really want to push the effect of light coming through the wave. (At the risk of sounding cliché—*every* seascape painter is told to get light into the top of the wave.)

Focusing on the foreground now, Peter brushes ochre tones of *wet sand into the foreground, softening and blurring the edges of the eddies. A fine, irregular line of white warmed with cadmium orange and yellow, added with his palette knife, highlights their edges.*

Finishing touches

Peter continues to blend and soften the foreground. With his small palette knife, he adds flecks of ochre-toned white foam, saving his brightest whites for the center of interest.

Now he brushes ochre notes into the breaking foam.

P.V. — These ochres are light coming up from the sand below or through the foam. These touches of color add richness and contrast to the wave. It's amazing what a little bit of warmth there will do.

Peter continues to work in the foreground — softening edges, blending ochres and grays into the wet sand, further softening the foam.

P.V. — The breaking wave at left center is so strong I need another mass at right to counter it. I'll move the body of the storm cloud from left of center to right of center.

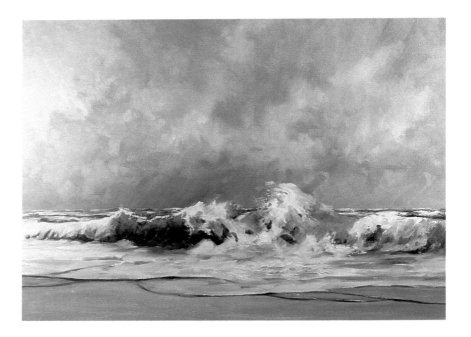

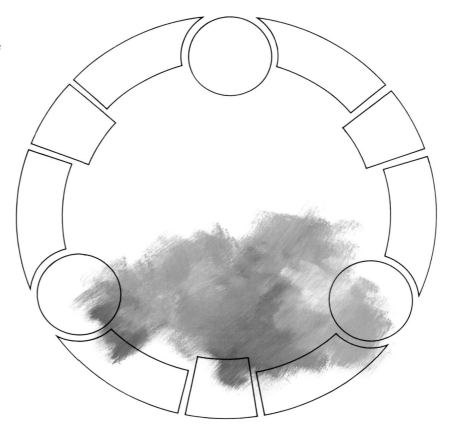

The Color Dynamic for *Ahead of the Storm*

A subtly analogous color scheme that ventures from neutral colors with just a few color accents.

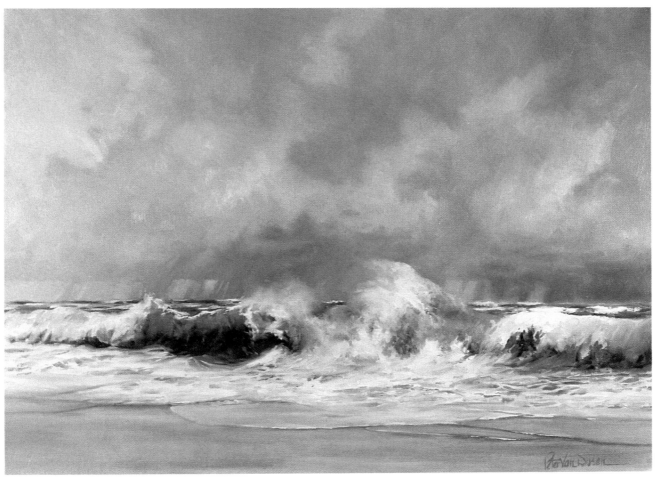

Ahead of the Storm
Peter Van Dusen
Oil on canvas
16" × 20"

The finished painting

He darkens the cloud mass at right, develops more rain clouds, and adds more streamers of rain.

Finally, after studying his painting for several minutes, he returns to the wave at right— blending in more blues, working the pigment into the foamy areas.

P.V. — Look at how those blues pull your eye into that area. Now it's strong enough to hold its own against the breaking wave on the left.

He stands back and studies his creation briefly; then he picks up his round sable and signs it.

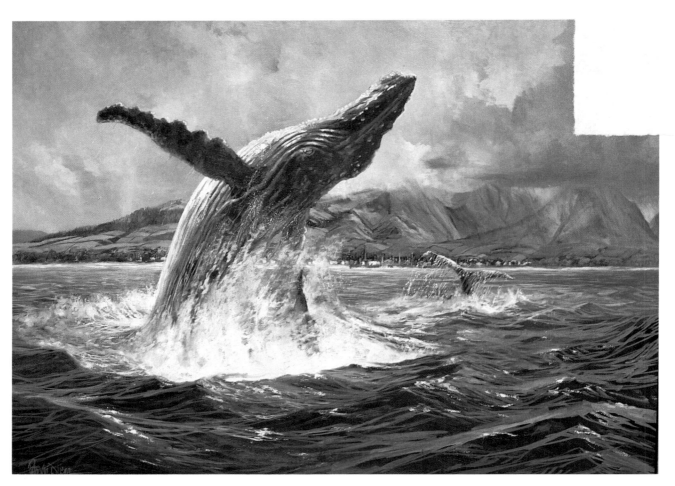

The Breach
Peter Van Dusen
Oil on canvas
30″ × 40″

The dominant colors in this energetic painting of humpback whales frolicking in the sea off Lahaina, Hawaii, are deep purple-blues and light, cool reds. Note how the red transitions through all the shades to lavender, yet maintains a light, airy effect, while water and whale shade both toward turquoise and lavender, remaining dark in value. The subtly green land separates the two, while the whale powerfully breaks through.

To me, this is a wonderful example of how the artist's use of color—and value—can enhance the viewer's impression of an overwhelming subject.

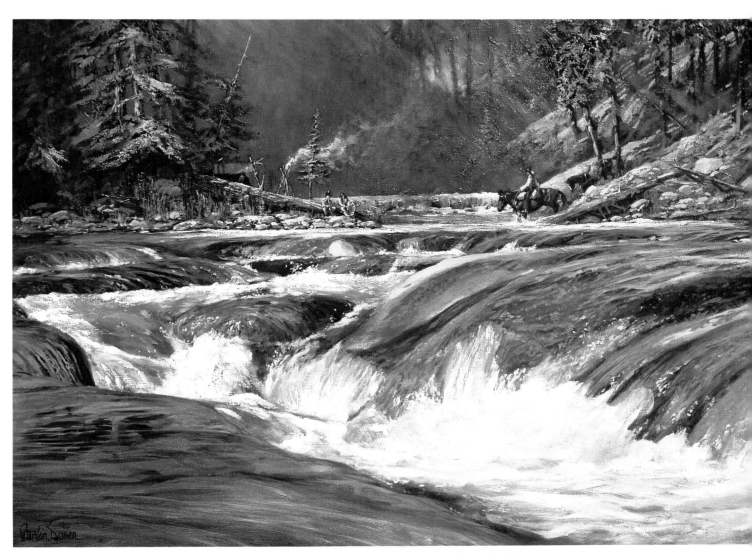

Beaver Camp
Peter Van Dusen
Oil on canvas
24" × 36"

A complementary color scheme is the basis of this refreshing painting. Oranges in earth and rocks contrast strongly with blues reflected from the unseen sky. The hazy background is lit with high-value hues of orange, red and lavender that shades to smokey blue. Light and dark greens lend color contrast, especially to that brilliant, sunlit red spot, the star of this composition. It is only after being drawn irresistibly to that center of interest that the viewer is apt to notice the other figures in the painting.

Notice too how Peter has backed the red with darker values of the colors around it for maximum impact.

For many artists this blatant bit of misdirection is what adds excitement and interest to a painting. What the viewer sees first is not the true center of interest; it will take him or her longer to discover that.

Chapter Five
Color Triads Unify a Painting

Raleigh Kinney paints a Sunday on the beach

Picture this: your blank canvas or paper before you and your palette laden with twenty or thirty different colors—several hundred if you're a pastelist! Is it any wonder that sometimes the color harmonies of your finished painting seem scattered to the very corners of the visual spectrum?

One effective way to unify a painting like this is by narrowing the number of colors you use. You can see that happening in Joni Falk's demonstration painting in chapter 3. Another method, which affords some added benefits, is to base the painting on a *triad* of colors: variations of the three primaries—red, yellow and blue.

Rather than limiting the artist, triadic color schemes actually assure that, because just three colors form the basis of all hues in the painting, the underlying continuity will help unify the finished work.

Watch this approach at work in this chapter, as Raleigh Kinney demonstrates a triadic color scheme as he paints *Sunny Sunday*. Raleigh says, "I try to find a common warm or cool thread to my triads. Warm red works better with warm yellow and warm blue. Cool reds seem to go better with cool yellows and greenish blues. When there's a good fit, colors stay brighter and don't turn muddy."

The preliminaries

As his subject Raleigh has se-
lected a fairly ordinary snapshot
of a beach scene. His first step is
to translate this theme into a
"value sketch"—to organize the
composition of the painting and
to determine where light and
dark values will be massed.

R.K. — In my sketch I've placed a
mass of dark values below center,
running left to right, and another
running vertically along the right
side. My center of interest will be
at lower left center, and that's
where my greatest color and value
contrasts will be too.

I'll place the umbrellas at vari-
ous levels, use lots of color, catch
the brightness of the sunlight, go
for nice contrasts between simple
and complex areas and lights and
darks.

Raleigh refers more to his
value sketch than to his photo as
he prepares a detailed drawing
on his Arches 140-lb. cold-press
paper. When that is ready, he
proceeds to thoroughly soak his
paper, front and back, using a
spray bottle of clean water.

R.K. — Rather than stretch my pa-
per, I prefer to let the water relax
it and make it very flat. I prefer
working this way because it pro-
longs my working time, gives me
smoother transitions, and keeps

1

the soft integration of shapes and
colors for which watercolor is so fa-
mous.

I try to think of a painting as
evolving in three phases: lights,
medium values and accents. First,
I'll develop the movement of a large
mass of color. Second, within that,
I'll add a major movement of mid-
sized, middle-value shapes to carry
the composition. In the third
phase, I will establish my darkest
darks and my details, and focus on
my center of interest.

Raleigh removes excess water
from the surface by rolling a pa-
per towel roll across his sheet;
with the now evenly dampened
paper before him, he takes up his
3-inch brush.

Phase one: The lightest values

R.K. – In this initial stage, I'll lay down about a 30 percent value, trying to define shapes as I go. This is the most important part of the painting because it will define where my lights and darks will be in the finished piece.

For my triad, I'll be using rose carthame (which is a little warmer than a Winsor red), permanent yellow and cobalt blue. I particularly like cobalt blue for its ability to allow the other colors to show through, unlike some of the other dye-color blues, which cause the reds to turn black.

Raleigh wets his 3-inch flat brush, then dips one corner into his premixed yellow wash, the other corner into premixed red.

R.K. – The best way to achieve entertaining color is to work with two-color mixtures of your primaries. That way, you'll get the purest mixtures because that third color won't be there to neutralize them.

Beginning at left, he applies color in the negative areas above the umbrellas with first the red corner of his brush and then the yellow corner. A second brush, dipped in clean water, is used to soften and blend edges.

R.K. – I'm not so concerned at this stage with the shapes I've sketched, though I am trying to tie them together. I am watching my value sketch and am most involved with getting colors down in a fresh and interesting way. I am not at all concerned with subject matter, which will take care of itself.

Raleigh continues to work his way to the right, replenishing the brush from his palette. Arriving at the right edge, he continues downward.

R.K. – I have good control because the paper is damp. I can have

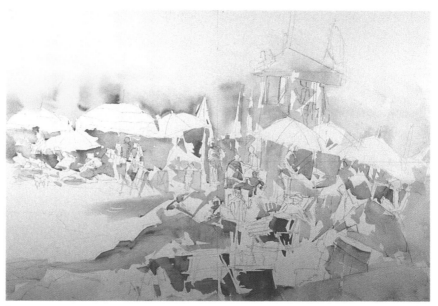

2

hard edges or I can blend them easily with the paper's surface. I can recreate this situation over and over again, simply by drying the paper and re-wetting it. This method allows me the most control and achieves the loosest, most painterly effect.

Bright areas alternate with subdued passages as he goes; the pigments blend in his brush and on the paper to add an element of entertainment to the surface, a distinctive trademark of Raleigh's style. Soon most of the sheet is covered with paint, and he pauses to dry it with his electric dryer.

Pouring color for maximum intensity

Raleigh thoroughly re-wets his sheet, then rolls it with his paper towel roll, reestablishing the even dampness of his paper. He discards the outer, pigment-soiled towel layer after each pass.

R.K. — The key to a sparkling painting is to let your whites work through as much as possible and to place your darkest darks close to them.

Raleigh has three small squeeze bottles filled with strong mixtures of his triad colors. Taking up the red, he squirts a lima-bean-sized puddle of paint onto the paper at top right. Then, before it has a chance to run on the slightly tilted board, he controls it with his moistened 3-inch brush.

R.K. — This is how I get a lot of paint on the paper quickly. Then I carry it along with my brush. If I can manipulate the color with my brush, I'll have no need for masking fluid, and the damp paper will still give me all the control I want.

Still more paint is squirted on the paper and spread with the brush. The board is leveled, then tipped, which encourages the paint to flow in other directions. A spray of clear water dilutes some areas, softening the edges. Then color is pulled through and around the lifeguard tower with a moistened brush. While still wet, excess color is lifted off with brush or tissue.

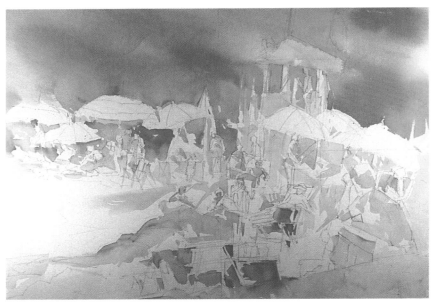

3

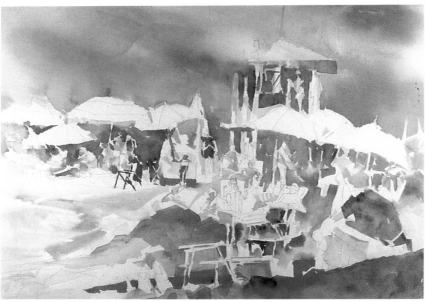

4

Red is now dropped into the under-umbrella areas at center and blended with the brush. Then Raleigh dries his sheet once again.

Phase two: The middle values

R.K. — Now I'll be working with cobalt blue and red on the opposite corners of my brush, getting the colors to mix on the paper rather than in my palette.

Starting at center, Raleigh brushes in strong values of cobalt blue, moving them toward the left, cutting in negative shapes, alternating red with blue to give constant change to the color passages.

R.K. — Everything in a painting is relative: darkness to lightness,

color to color. Excitement comes from the purity of color next to color. Alternating colors, as I'm doing, generates gems of varying mixtures throughout the surface.

Raleigh cuts in more shapes below the umbrellas at left, with the middle ground emerging from background and foreground as he goes.

R.K. — I tend to look at this as an abstract painting at this stage. In fact, my design is much more abstract in terms of lights and darks than in terms of subject matter. How much do I really need to say? I give my viewers little clues as to what's going on, and they complete much of it in their own minds. I want to move viewers from one area to another by linking darks, lights, shapes and colors.

Raleigh now works on the tower area—washing in darker blues, softening edges into already-painted washes with a clean, wet brush, painting around the small figure there. Then returning to the midsection, he continues to add blue into the background, from the center to the right edge.

R.K. — I try to define no more than 30 to 40 percent of my subject matter, keeping the rest suggestive of shadow pattern. They'll be interpreted as real shapes. I'll pick out a few heads, save some fleshtones.

Now Raleigh works at bottom right, adding blues and greens, then darker values, carrying the horizontal band of detail and color down and clockwise toward the left, merging it back into the area below the tower. The wash turns warmer where he delineates the beach chair at lower center and continues left along the bottom.

R.K. — The strong red gives me a dominance of hue throughout the painting, which adds a nice feeling

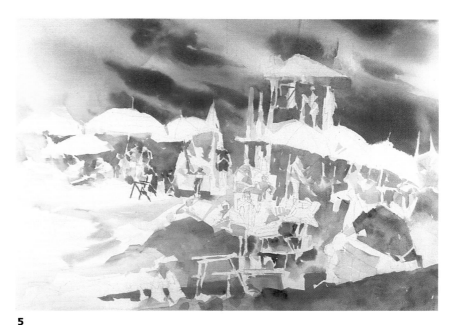

5

of unity. Getting a lot of color on the paper and having all the other colors work out of it are what make it work. And I've still only used three colors!

Completing phase two

Having dried and re-wet his paper, Raleigh wields his squeeze bottle of cobalt blue, squirting color into the sky area, spreading and softening it with his 1-inch brush, repeating the process several times.

Now he holds his painting with the top left-hand corner down and sprays water vigorously onto the sky area, blasting paint out of the darkest areas. Laying the painting flat once more, he dries the now softer, lighter sky area.

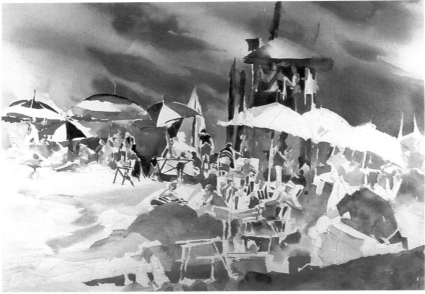

6

Phase three: Contrasts, details and color accents

R.K. — In the third stage I'll be creating my strongest value contrasts. This will be the accent layer, the finishing layer.

I'm still working with dampened paper, getting a variety of edges, and that's fine. I'm switching to thalo red rose and ultramarine blue now for my darker and stronger accents.

Utilizing a mix of the two colors, Raleigh lays in dark masses and shadows to the left of the tower and around the figures beneath the umbrellas. Further dark accents are carried leftward in the detailed area below the umbrellas.

R.K. — I'm always looking for contrasts: light against dark, dark against light. If it's dark against dark, I try to have as much color contrast as possible.

Raleigh is giving great attention to the areas below the umbrellas now: dotting in small details with the corner of his 1-inch flat brush, using blue to tie the many small shapes together, pushing white areas back into the shadow, elaborating highlight areas with details, putting in tiny areas of cobalt turquoise as accents. He still frequently refers to his value sketch. Using a toothbrush, he scrubs color out of the tower roof and the sailboat's sail. Brown madder alizarin is used to create dark accents around the base of the tower.

The Color Dynamic for *Sunny Sunday*

The strength of the red-yellow-blue triad remains dominant, with just a few blends in purples and oranges to relieve the intensity.

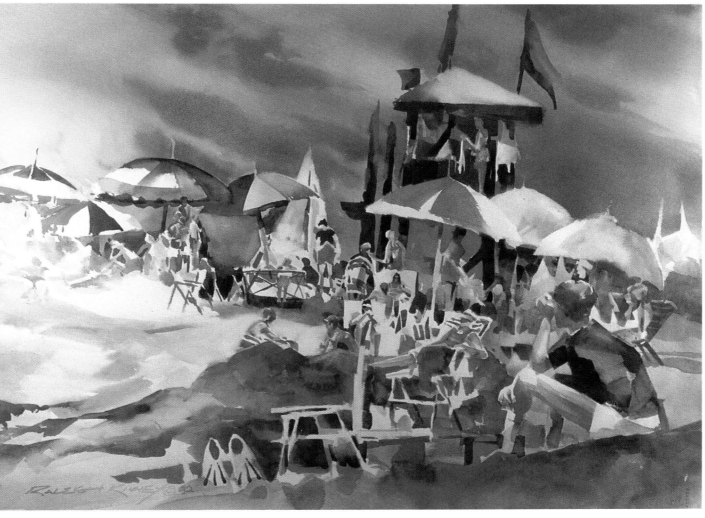

Sunny Sunday
Raleigh Kinney
Watercolor
22" × 30"

The finished painting

A warm blend of red and yellow is dragged out to the lower left for sand texture, forming a quiet contrast to the busyness of the center.

R.K. — Now I'll develop some of the inner darks and values. I really want strong shapes around my center of interest, and for that same reason, I'll push the contrast there.

Raleigh adds red and blue to an umbrella in the mass at right, subtly tying together the other umbrellas with blue to establish the overlap pattern.

To warm the composition and focus attention on the white highlights in the midsection, Raleigh lays a glaze of yellow over the entire sky. He makes a few minor adjustments and, declaring the painting finished, signs his name with a flourish.

Sedona Clearing
Raleigh Kinney
Watercolor
22" × 30"

While the powerful red of the mesa is clearly the center of interest in this piece, it's what is happening around it that makes the painting work.

Beginning with Winsor red, cobalt blue and Naples yellow, the artist augmented his triad with accents of raw sienna, cerulean blue and French ultramarine.

The sky was created with three separately dried washes. Naples yellow first, then red, and finally blue. Re-wetting the paper each time, Kinney blends layers without losing the purity of his colors.

Four Aces and a King
Raleigh Kinney
Watercolor
22" × 30"

This painting is built on a triad of Winsor red, aureolin yellow (with raw sienna), and cobalt blue, its unifying foundation.

The vitality in the painting comes from the play of negative against positive, the rhythmic repetition of shapes and forms, and the color variations that occur within each area. The artist has placed warms next to cools, and neutrals next to high-chroma colors. Notice particularly the shadows filled with warm and cool hues.

View South From Sedona
Raleigh Kinney
Watercolor
28" × 41"

The triadic colors that underlie this painting are Winsor red and raw sienna (which when blended create a warm, lively variation of burnt sienna) and cobalt blue. The lavenders in the sky were created with a touch of alizarin crimson. Cerulean blue, in the sky and reflections, imparts a granular texture to those areas.

Jerome
Raleigh Kinney
Watercolor
22" × 30"

A high-key triad helps unify this light and airy study of an old Western town. Values are kept in the lighter half of the scale. Rose madder genuine, aureolin yellow and cobalt blue were selected for their transparency and nonstaining characteristics.

Paint was applied in separate layers, then lifted off to recover the whites. The light, airy transparency of the artist's technique lends an entertaining and decorative aspect to the work.

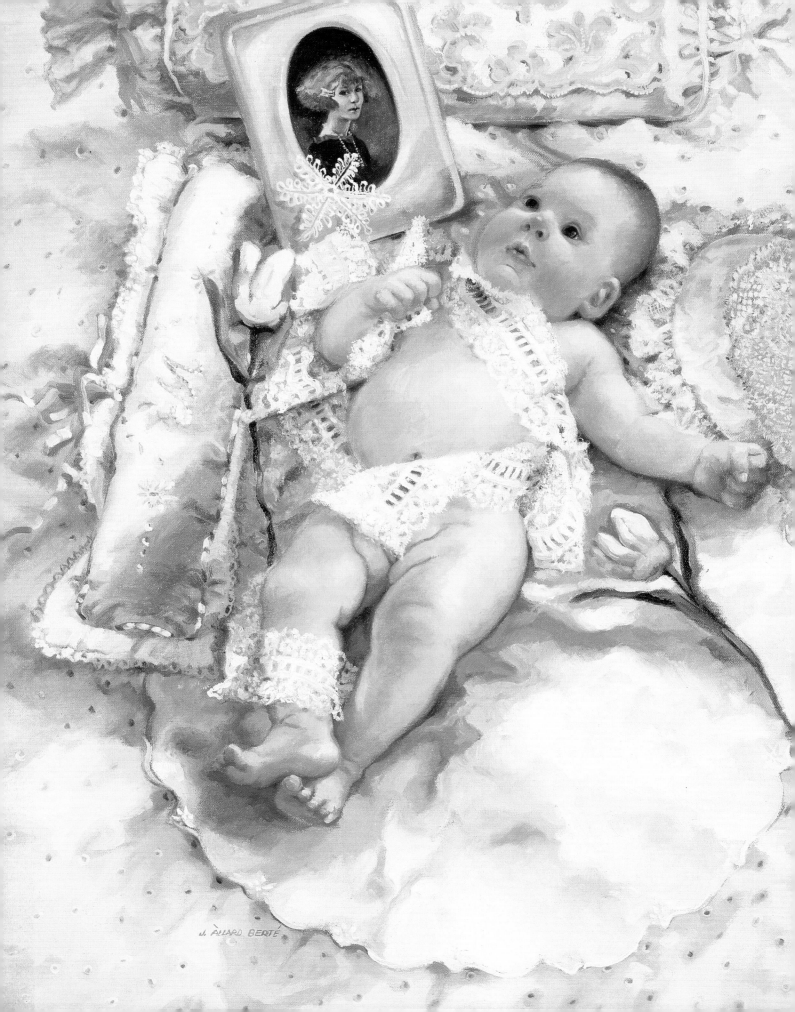
J. ALLARD BERTÉ

Chapter Six

Using Color to Tell a Story

Lauren — Still Life for Grandma
June Allard Berté
Oil on canvas
30″ × 28″
Collection of Mr. and Mrs. Ernest Malone, Jr.

A portrait? A still life? A nostalgic memory painting? This delightful piece is all of these. Naturally, warm pink is the pervasive color in this painting. But see how the cooler pink of the two flowers pushes the warm hues even warmer, and how the blue of the pillow at top serves as color contrast and relief.

June Allard Berté paints a memory

What color are memories? You can find them in the gold of cobwebbed sunlight slanting through a dusty attic window. They can be evoked with the dusty mauves of forgotten sunsets or in the golden browns and sepias of fading snapshots in a crumbling photo album.

Memories are fertile material for any artist. Your own mementos can be put together to create a composition which, because it holds special meaning to you, will touch others who view it as well.

Portraitist/genre painter June Allard Berté is no stranger to this sort of subject. Many of her assignments involve assembled memories, and she accomplishes these commissions with skill and sensitivity.

In preparing for this painting, June assembles items from her personal collection, arranging them to weave a tender story, which she will title *Lost Love*.

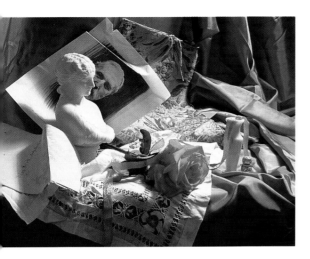

1

The subject

J.A.B. — I've chosen this marble bust of a rather introspective young woman, a love letter, a vase and a perfume vial, a lace cloth and a rose. That stern man in the engraving: Is he father? Lover? Interpretation, as always, is up to the viewer. That's part of nostalgia's charm and memory's mystery.

Because this will be a romantic painting, my palette will be based on sepia tones, lit with a soft, golden light.

Getting started

Using raw-umber oil paint thinned with Turpenoid, June begins scrubbing in her composition.

J.A.B. — I keep this simple because I want to be able to change things around. I'll block in around the flower area to keep that as fresh as possible.

L.L. — Are you giving any thought to color at this point?

J.A.B. — Not really. First I need to establish my composition.

She scrubs in the shape of the engraving.

L.L. — With a subject like this, how closely do you stick to what you're actually seeing?

J.A.B. — I do like to paint what I see. At the same time, I've come to realize that an artist has to employ instinct as well as intellect. My instinct tells me I don't have to paint exactly the way I've set this up. So I'm free to alter things: proportions, values, colors — even elements — as I proceed . . . totally unlike the photo-realists! Right away, for example, I can see that I'll change the proportions of the man's head to put it into better relationship with the marble bust.

Scrubbing in color

L.L. — What is your approach to color?

J.A.B. — I tend to be a "tonalist," that is, I work with a pervasive hue — a "mother color" — which is the starting point for most of my mixes. In this painting, that will be the burnt sienna/yellow ochre part of the spectrum.

I use Maroger as my medium. [Maroger is a quick-drying, gel-like medium.] I love the buttery way it makes the paint feel on my brush and on the canvas. My colors stay rich, and I'm able to work over things within a very short time.

For the background I've mixed burnt sienna with Davey's gray as my middle tone. I'll lay in my lightest and darkest values and my brightest colors later. Between steps, I alternate laying in color and scraping it down with my palette knife.

Beginning at upper left, she works clockwise around the canvas.

J.A.B. — Sometimes artists feel uncomfortable with how their painting looks at this point. They strive to make it "lovely" as early as possible. It's more important to pull it together first.

Starting on the letter, she mixes cadmium yellow, yellow ochre, and a little Davey's gray, cooling the shadow with cobalt violet. With violet still on her brush, she carries it upward.

2

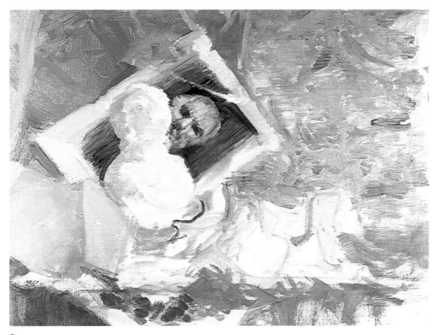

3

Establishing the value range

Turning now to the engraving, June begins where it meets the bust.

J.A.B. — I always have to think about adjoining values when I paint. You'll see how this dark will make the bust lighter.

She scrubs in the deep values with strong vertical strokes.

J.A.B. — I want to maintain the monochromatic feeling of the engraving, though I'm warming my black with burnt sienna.

She lays in facial shadows, then with warmed light gray, works back to establish the shape of the head, adjusting highlights and shadow values as she goes. Yellowed hues are brushed around the edge of the engraving to suggest light coming through the paper.

J.A.B. — Now for the bust. There's a lot of warmth here . . . a lot of light bouncing in. I'll establish shadow values here too.

She dabs light gray on the forehead, adjusting its value several times. For highlighted areas, cadmium yellow and orange — just a touch — are added to white.

Alternating between highlight and shadow, she begins to build the shape of the bust. Then warming and deepening the shadow tone, she defines its back-lit left edge.

J.A.B. — When I have a color on my brush, I like to look for other places to use it.

Mentally, June enlarges the swatch of brocade to fill the right background. Painting against the shapes, she suggests the weave of the fabric with choppy *horizontal brushstrokes.*

J.A.B. — I'll mix cool pinks using alizarin crimson and a touch of cadmium red deep to create that beautiful rose color.

The background cloth that will show through the lace is laid in with shadowed values.

Building relationships

As the composition begins to take shape, June suddenly digresses, daubing in red where the rose will be.

J.A.B. – I want to see my color range.

Returning to the bust, she begins to establish features, alternating shadow and highlight.

J.A.B. – In effect this is a mini-portrait, so I'm using a smaller brush than usual to lay the features in.

Neutral shadow grays become warmer where the bust catches bounced light from the left. Deeper shadows are added.

She alternates between working on the bust and engraving, blending edges where they adjoin, adding touches of orange in the shadows.

J.A.B. – I want to keep the man's eyes understated . . . mysterious.

As values become established, June reevaluates nearby areas and lightens the yellow of the letter to bring it into balance. Yet something's bothering her.

J.A.B. – I can't get the bust light enough, which makes me realize that some of the other values are not dark enough.

She lays in a dark value at the back of the head, which makes the paper of the engraving look lighter. This, in turn, makes the background look darker. Now the highlight values work better, and June continues to define the features.

J.A.B. – I'll go back to the brocade now to develop that a little more.

Working her way down, she lays in the vase, darkens the extreme foreground, tentatively lays down a gray for the shadowed lace cloth, and adjusts the

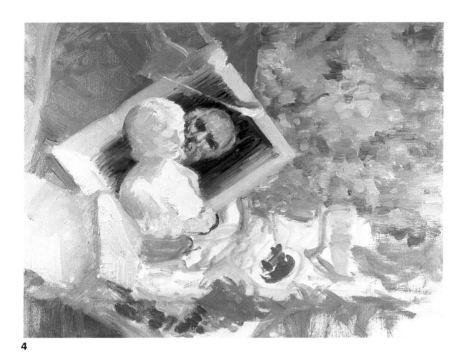

4

warmth of the sienna background against the engraving.

Flower time!

June mixes cadmium red light and Dutch vermilion crimson on her palette, pulling a darker value to the rear, a lighter value to the front. She begins with the shadowed left side of the rose by mixing in a complementary green, then digresses to establish the gray of the cloth, adjusting its value against the rose.

J.A.B. – The value relationships have to be just right.

She carries the gray left, along the bottom edge of the painting, pausing to scrub in the sienna that will show through, then coming back with gray in the lace work.

J.A.B. – I mix a bit of cadmium green light in with my burnt sienna, a technique I learned from Joe Bowler, an artist friend and mentor.

Returning to the rose, studying it carefully, she works in the

darker values with a cooler red, then paints the bright, hot, highlighted petals.

J.A.B. – White would become chalky, so I lighten my red with yellow.

Now she begins to lay in green leaves, first darker, then lighter, framing the blossom and accentuating its brightness.

Picking up rea, then white, on her brush, she highlights petal edges; the colors blend only slightly on the canvas. Finally, she adds the deepest red at lower left. Strokes of white establish the right edge of the flower and are connected with the grayed values below.

With the gray of the cloth in place, June realizes that the shadowed values seen through the lace are too light. She darkens them, continuing this value at lower left. Then the cloth is repainted with sienna-warmed gray.

J.A.B. – I try to keep it simple. If I paint every stitch there, the cloth will become too important.

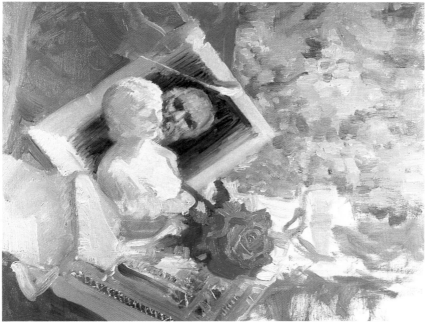

5

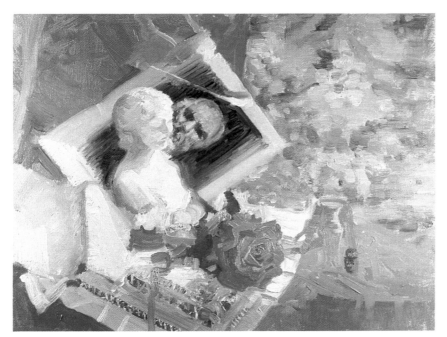

6

She works white around the leaves of the rose, remarking how both white and dark green emphasize the red of the blossom.

Solving and resolving

J.A.B. — It's time to deal with the right side of the canvas . . . time to define these secondary elements.

Dipping into her darker sienna tone, she brushes shadow values across the bottom right.

J.A.B. — I'll simplify the drapery here; give the feeling that it's the edge of a table.

She shadows the vase, fusses with highlights in the cloth at bottom left, adjusts shadow values at the extreme lower left, and carries that into the holes in the lace.

J.A.B. — Back and forth — it's never quite perfect. It's laying in shadow, then laying in lace, then going back to the shadow again.

She brushes in the length of the ribbon with a series of single, quick strokes.

J.A.B. — I've just got to lay that in and let it be.

She picks up both white and yellow on her brush, making no attempt to blend them and lays in the ribbon highlights.

Instinct over intellect

June has taken some time away from the painting and now returns to look at her subject anew. Discerning that still stronger value contrasts are needed, she attacks the background at top left, darkening and breaking up its continuity.

She works around the bust, adjusting shadows and highlights.

The letter at left is lightened still further, and the light it bounces to the bust is pushed even warmer. Ribbon highlights are brightened. More green leaves are added around the rose.

After working over the whole painting for a while and adjusting colors and value relationships, June stops, ponders, then comes to a bold decision.

J.A.B. — The whole right side of the painting bothers me. It's unresolved, and I'm just seeing it for the first time! I'm going to darken the background, get rid of the whole lower right area, and extend my main elements to the right.

With a glaze of sienna and Maroger medium, she scrubs over most of the brocaded area, subduing and darkening it considerably. Then she restores just a little of its texture. The area immediately drops back.

The white cloth is extended to the right, tentatively at first, then more assertively as June evaluates the effect. Vase and perfume vial disappear entirely!

J.A.B. — Just because the setup looks that way doesn't mean I have to paint it that way. I wasn't happy with it, and I had to work that out. That's instinct over intellect!

A rosebud, created out of June's experience and imagination, appears atop the white cloth.

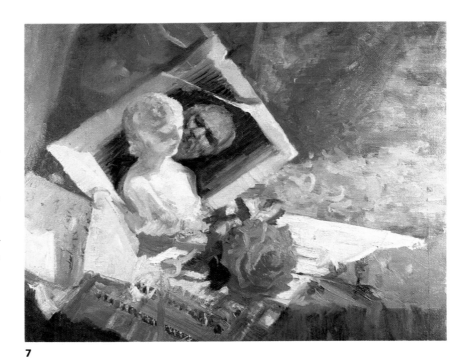

7

The Color Dynamic for *Lost Love*

The golden light that pervades this work is quite evident here, with only the slightest color complement to set it off. The secondary red/green color complement is virtually the only other dynamic.

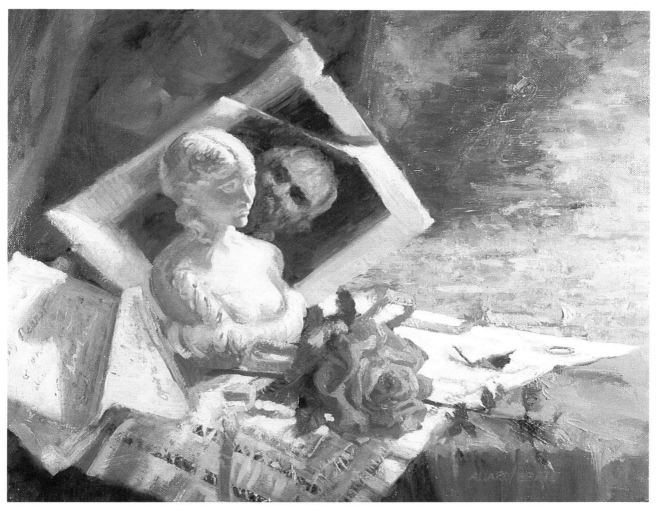

The finished painting

The problem area resolved, she returns to the bust, working on values, features, and the colors of bounced light that illuminate it.

In completing the painting, June pays close attention to the bust, observing and rendering it in careful detail. As befits a portrait, its face bears the only really precise detail in the painting.

A gold ring, a leaf and the ribbon are added at right to add interest and help move the eye through the restated section.

Particularly noteworthy is the *complementary light blue she adds in the shadowed cloth. Repeated elsewhere in the painting, it adds life, further emphasizing the pervasive warmth of the piece.*

J.A.B. — A painting like *Lost Love* has to be approached on several levels: first as a composition . . . carefully placed elements that tell a story. But just as important, the colors, the values, even the textures the artist employs — they're like mood music — contributing to (or taking away from) the story.

Lost Love
June Allard Berté
Oil on canvas
16" × 20"

Harrison Cherub
June Allard Berté
Mixed media
22" × 30"
Collection of Lola and Lewis Lehrman

This "cherubic" little fellow is our own grandson, Harrison David Lehrman. We commissioned the piece when the little guy was six months old, shortly after we saw the first of June Berté's popular "Cherubs" series.

The media mix is unusual: graphite pencil, India ink, 22-karat gold leaf, and gold jewelry findings, on bristol board. How many of us have ever considered gold leaf a color medium? In this instance, it has been loosely applied to the surface, the wrinkles in the leaf emphasized to add color and sparkle.

Roberta & the Gold Leaf Screen
June Allard Berté
Oil on panels
72" × 72"
Collection of Mr. and Mrs. R. Keith Berté

The concept behind this impressive screen owes much to the influence of the French "La Femme" or "Japonisme" school. Late-nineteenth-century European art was strongly influenced by the popularity of Japanese woodblock prints depicting beautiful women.

The screen within this screen is beautifully rendered in warm yellows and oranges that carry the continuity through all three panels. The tumbled, green fabric on the chair offers strong complementary contrast to the nearly life-sized figure that looks out at us from the center panel.

Note particularly how the artist has placed the hinged joints of the screen so the panels can be set at any angle without producing visual distortion of the image—along the joints of the painted screen, and in formless leaves and fabric.

A screen such as this can be a daunting challenge to any artist—especially since it may involve not only artistic, but also cabinetry, skills.

Grandmother's Vase
June Allard Berté
Oil on canvas
36" × 21"
Collection of Dr. and
Mrs. Erik Rosenthal

''Lindsay,'' says the artist, ''was a natural model. The vase belonged to her grandmother and was a family heirloom. I photographed the child in many poses as part of a portrait assignment, and did this study from several photos.''

The elements in this sensitive painting are, of course, meaningful primarily to Lindsay and her family, telling a story both personal and enduring. This unique ability to blend imagery, symbol and emotion is the hallmark of an artist well accomplished in storytelling.

Chapter Seven
Color for Powerful Imagery

Ted Goerschner paints a Southwestern scene

To most of us, a painting is a window through which
we look into the world an artist has created. When
the illusion is successful, it seems as if we might
even step into that world—stroll down the path,
through the gate, around behind the house, and out
toward the distant mountains.

But it's just an illusion. That window onto another
world is, in reality, a flat surface. And this is one area
where the figurative and the abstract painter part
company. While the former seeks to create the
illusion of real space, the latter acknowledges—and
deals directly with—the painting surface.

Figurative painters like to say that they work with
shapes and values and color relationships quite as
diligently as do their abstract brethren: "It's just that
our abstract shapes become houses or trees or
objects," they say. A philosophical conflict? Not
necessarily.

The color and value that energize a painting
function regardless of whether they are describing a
scene or existing purely as color and value. That's
why when an artist like Ted Goerschner creates
paintings that bridge the chasm between figurative
and abstract thinking, his thought processes are
worth following.

Color basics

Eager to learn Ted's methods, I watch him set up his palette. He squeezes out large blobs of light gray — warm, neutral and violet-cool — from three unlabeled tubes, explaining that these were blended of leftover paint scraped from his palette. He adjusts value and color temperature, then scoops the mixtures into empty tubes he buys for that purpose.

T.G. — Edgar Payne used to call this "soup." I call it my "mud."

His palette includes the usual assortment of spectrum colors: cadmiums, very few earth tones, viridian and sap green, no black. Nothing startling here.

L.L. — Do you use medium?

T.G. — I used to, but not anymore. It breaks down the viscosity of the paint, makes it do things I don't like. Paint usually has the right amount of oil already in it, so I prefer to leave it at that.

On a piece of scrap canvas board, Ted demonstrates his approach to color.

T.G. — This is how I expand my colors to get the most out of them:

I establish a color first, then pull it analogously both ways, warmer and cooler. Then I pull its complement through the center, to neutralize it. For instance, the middle hue on this board is viridian. I can warm it with yellow, cool it with blue, neutralize it with red.

A lot of students have trouble with this. They don't understand that high chromas are to make the color expand, and complements are to neutralize it. Never get grays into your high-chroma colors. Keep them pure when you want to get the most out of them.

Getting started

Ted's demo painting is to be built around three snapshots he's brought with him.

L.L. — What do you use to tone your canvas?

T.G. — Mud from yesterday's painting, tinted to a warm tone. I'll brush that on and wipe it back out

to get a medium value. Then I'll sketch my composition with burnt sienna and a touch of terra rosa.

L.L. — Have you already planned your colors?

T.G. — I've got them in my head, my darks against my lights. My chmisa [a yellow flowering shrub] will be light against the dark of the adobe for depth. My colors will be complementary — warms against cools, reds against greens, with a bit of yellow thrown in. Almost but not quite triadic.

1

Blocking in boldly

He begins laying in pure white on the end of the building.

T.G. — After my composition is sketched in, I establish a good strong point of interest and start there. This will be the most contrasty area.

He mixes highlight color for the adobe and then strokes it in generously.

T.G. — I like to load up my brush and lay it right in there like peanut butter — push it around, let things happen within the strokes. Don't mix it thoroughly. Let it marbleize on the canvas. Throw a little complement in every once in a while.

He lays in the shadowed side of the adobe.

T.G. — I'm blocking in my big shapes. A bit of viridian in that shadowed red. Warm dark for my window — alizarin and ultramarine.

I want to keep the building hot . . . the roof warm . . . magenta, orange and a little white . . . pushing my color. That will be my base color; later I'll go back and blend in other colors. Everything is relative in a painting. So I can't complete one area until I do the ones around it.

The center of interest will be near the shed at the left. I want it to be good and strong.

He mixes violet and ochre, loads his brush, and strokes it into the shed.

T.G. — That'll look great in the roof too. Cool neutral against warm neutral.

Laying on a great gob of viridian darkened with ultramarine and warmed with raw sienna, he scrubs in the tree mass at left and blocks in the trees at right.

At far right Ted mixes a little green with his "violet mud" and adds a dead tree, its color in harmony with the larger green mass.

2

3

T.G. — In subordinate areas of the painting, where I'm not trying to say too much, I keep my values closer together. My edges will usually be softer in those areas too.

Shapes and values, fresh and clean

He turns his attention to the windows on the highlighted side.

T.G. — A white frame will make this read a little better. Later I'll bring the edge back with the wall color. A bit of blue in it will reflect the sky, make a nice little painting within the painting.

Ted begins establishing the chmisa in the foreground with cadmium yellow, working out-

ward from the center of interest.

T.G. — Now I'll work on the mountain, to push that back.

He scrubs in greenish gray near the top, then a darker gray near the cupola on the roof; he adds white to its left.

T.G. — I'm blocking in background forms now, trying to relate the near and distant greens. Once I have that, I can pull my forms out.

Ted scrubs blue into the sky, blends it with white, and expands the tone right and left, blending and softening the edges.

T.G. — I'll build this tree now, organize the values.

He yellows his green, adds it to the tree at left, then repeats the

same greens to the far right, so the color will connect across the painting.

He scrubs whites through the sky, tying shapes together. He scrapes paint off the canvas to the right of the cupola and brushes in more white, working subtle value changes around it, adding violet-gray to push it back.

Foreground concerns

T.G. — I'll treat the chmisa like a design and not try to put in every little flower. As much contrast as possible here, keying it for light coming in from the left.

Now to the foliage in the foreground: viridian, plus sap green . . . full hue, no grays, just a little burnt sienna to darken it.

He scrubs in the foreground shadowed foliage below the yellow and extends it down.

Moving to the right middle ground, he neutralizes his colors.

T.G. — I don't want a lot of contrast back there. Subordinate areas are important because they bring attention to the dominant areas. Get too much going on, and the whole painting says hello to you at once.

He brightens up the small house at right, then suddenly adds a bright red-violet passage to its right.

T.G. — That's just because I like it. It's red/violet against the blue/green, which is nice. Doesn't matter what it is. Call it a purple dumpster if you must.

I want to get my major shapes working in the foreground now. Right now the flowers are one-third, the shadowed foliage two-thirds. That's good. Too balanced is boring.

He returns to the building and shadows, adjusting values as he goes, judging relationships of

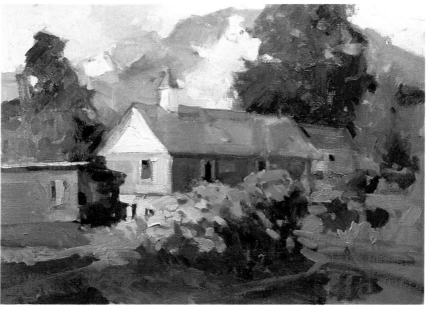

4

shape, color and value, making sure there is dominance and subordinance — that nothing is quite equal in importance to anything else.

L.L. — Do you concern yourself with whether any of these colors might occur in nature?

T.G. — I'm thinking of this more as an abstract composition than as a scene . . . putting the colors together the way I wish they were. Why limit yourself to painting what's there? You could take a photo! I'm painting realism like an abstract painter!

The pure joy of color

T.G. — One of the hardest things to learn is just to enjoy color as color. Sometimes just the color itself will inspire you.

Ted lays in brilliant red on the roof, repeating it on the building behind it. Dark red is brushed in at lower left, and violet fills holes at middle right.

T.G. — I'll bring this road around, in kind of an S-curve, just to get you into the painting.

L.L. — Still keeping things two-dimensional?

T.G. — Yes. Up to now, I've been mainly concerned with filling the canvas, getting my shapes down. Now I can start creating three-dimensional effects, pulling out lights and darks, and fine tuning.

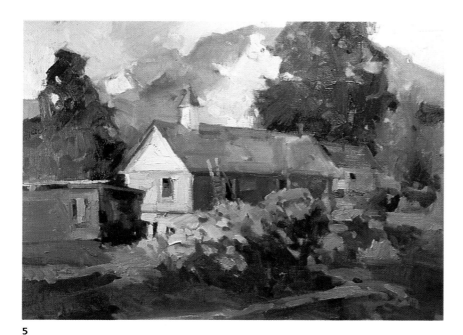

5

6

Refining the details

T.G. – Now I'll bring up the color, make the roof more interesting, bring some light through the center.

If I had to define the process, I'd say it was putting down two-dimensional shapes in relationship to each other, and then refining them. Paint that way, and your painting will stay fresh. I try to think abstractly right up to the moment I sign it.

He puts spots of highlight into the shadowed foreground foliage mass, allowing light to show through it.

T.G. – I love what light does.

He paints red highlights into the shaded side of the building, adds darker values there, adds pink tones to the roof, light yellow to the edge of the building at right rear (allowing light to glow between them). Raw sienna is added to the shed. The edges of the building are trimmed up. Grayed violet describes tree trunks, and highlights give them form.

T.G. – It's starting to work now!

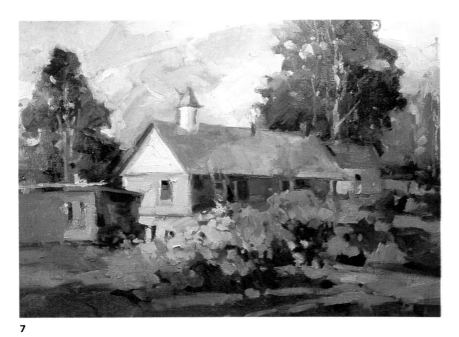

7

Finishing strokes

Ted continues to work on the foreground, varying his yellows, adding greens and lavenders, lightening and softening at left, and intensifying the dark violet tones.

T.G. — Sometimes I just go back and simplify shapes, seeing how much I can subtract out and still have it work.

Mountain shapes are simplified at top center and developed at right. Blue from the sky is bled into the mountain. Dots of orange catch sunlight in the tree, and at right, a vertical line of orange does the same. Highlights are added to the shed roof. Dots of violet are worked into the foreground. The edge of the roof is defined.

The Color Dynamic for *New Mexico Morning*

A high-chroma, warm-cool complementary color scheme, with bright highlights and accents.

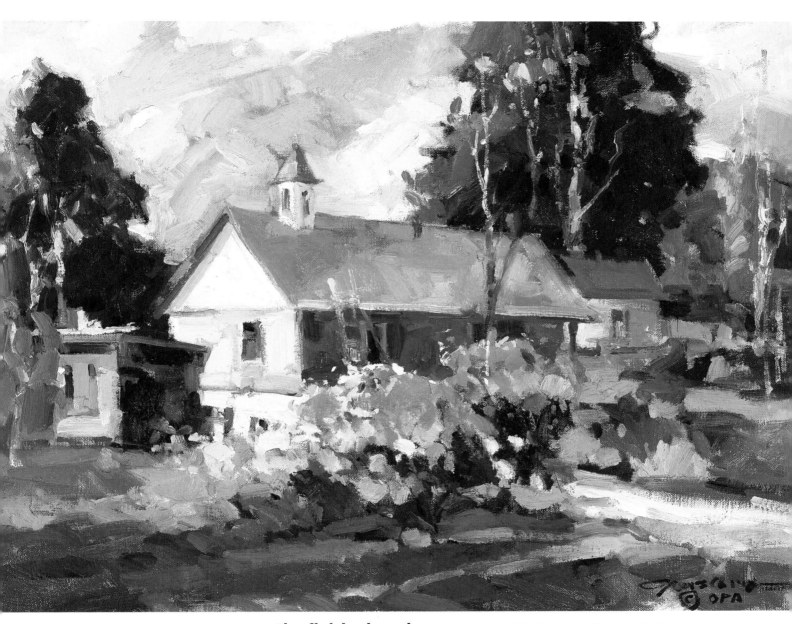

New Mexico Morning
Ted Goerschner
Oil on canvas
16″ × 20″

The finished work

White tree trunks are added at far right. A tree appears in the middle ground at left, adding depth.

T.G. — In the final stages, I add lots of color spots throughout.

He does just that: cadmium yellow light on the chmisa against the dark red of the building. Color in the trees at right, blue below the shed and across the foreground. A tree is added at right foreground, and the final touch, his signature.

High Sierra Color
Ted Goerschner
Oil on canvas
18″ × 24″

Is this an abstract painting with figurative leanings? Or is it a figurative painting that's strongly abstract? This energetic composition stands squarely and solidly between the two camps.

Try to visualize this as a purely abstract composition: rhythmic red verticals against high-chroma violet (analogous); against dark green masses at left (complementary); blue-green at lower left, rounding the color wheel from green to violet. Darks balanced left to right, lights moving throughout. The energies in this painting, in fact, have little to do with its imagery.

Valley New Green
Ted Goerschner
Oil on canvas
30" × 40"

It's the dominant analogous color scheme that energizes this painting. Ochre-tinged oranges shade through yellow, to myriad greens in the near and distant trees. Light-valued blue/purples shading to red/violets are the color complements.

Notice how strong the dominant colors are, staying right up in the foreground of the picture, while the lower-chroma blues and violets drop back. Only the overlapping of the foreground trees tells us there is a middle ground here. This denial of the effects of aerial (or atmospheric) perspective—the softening of hue and value as objects recede—makes this equally effective as an abstract or a figurative composition.

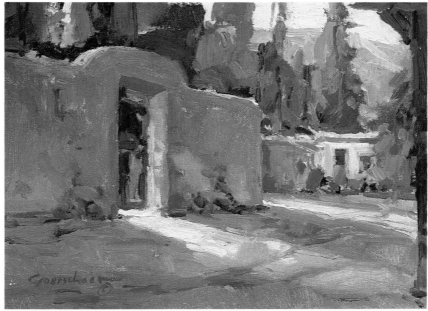

Canyon Road Adobe
Ted Goerschner
Oil on canvas
9" × 12"

The rich reds of the adobe wall are contrasted against the brilliant greens, blues and violets in the trees, background and internal shadows. Virtually all the colors in this composition are high-chroma hues, denying atmospheric perspective and keeping it essentially a two-dimensional painting—an energetic, near-abstract celebration of color on canvas.

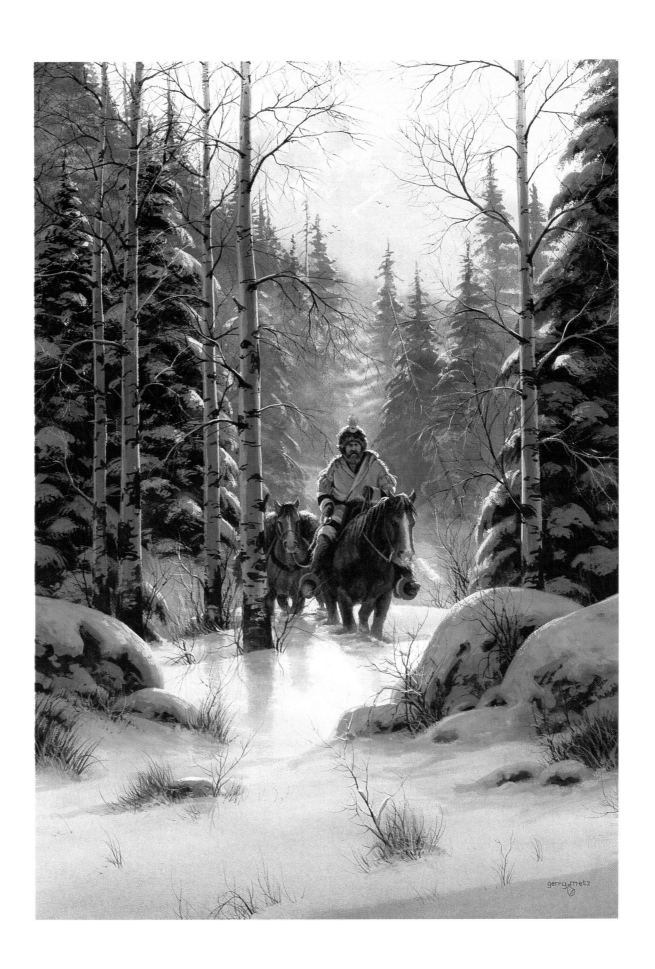

gerry metz

Chapter Eight
Using Color to Evoke a Time of Day

Gerry Metz paints an Old West scene

Gerry Metz illuminates his demonstration painting, *After the Storm*, with warm, late-afternoon light. The Old West is Gerry's milieu, and his extensive photographic library (not to mention his years of painting experience and his fertile imagination) readily yield locale, figures and artifacts for the composition.

The low-chroma blue/mauve cloud bank is a wonderful complementary color contrast to the intense golden light that pervades this scene, pushing the latter even warmer and brighter. This opposition is one clue to the way in which color energizes this painting, with its tightly analogous color scheme establishing and balancing its range of color.

Gerry Metz's medium is watercolor—with a twist. He tempers his transparent Winsor & Newton watercolor pigments with Shiva's casein white, so his passages may range from transparent to opaque. Even some impasto may be found on his painting surfaces.

This demonstration was painted on Whatman cold-press board, his preferred surface for paintings up to 20″ × 30″. For larger works, Gerry mounts the heaviest weight Arches cold-press watercolor paper to quarter-inch, tempered Masonite, using Elmer's aliphatic resin wood glue, a technique he has perfected over his twenty-plus-year career.

Getting started

A quick thumbnail to establish composition is translated right to the board; his pencil drawing is sparsely detailed except for the chuck wagon grouping, his center of interest, which is carefully composed from several sources, mostly historic old photos and the artist's own imagination.

Gerry masks out the grouping and the half-disc of the sun with masking fluid, to keep these areas clean until he is ready to work on them.

G.M. — I have to be really careful with this stuff, as it tends to lift the surface of the board when I remove it.

Adjusting his drafting table easel to a level position, he prepares to apply his initial washes.

Laying in color

An old hake brush is used to wet the entire surface. Then blending casein white with water to the consistency of milk, he brushes it over the entire surface.

G.M. — I learned this technique from John Pike. He recommended that if you're going to use opaque color in any part of the painting, use a little bit of it everywhere else.

This thin layer of white will come up to blend with my colors as I lay them down. Not only will this give the painting a cohesive quality that I like, but it will also allow me a little more working time with my colors.

The board is still quite wet, as Gerry uses his 1½" hake brush to wash cadmium yellow and new gamboge into sky and water. Diluted yellow and Winsor blue are touched into the upper sky, where they will show through the clouds to follow.

1

G.M. — I'll use indigo with alizarin crimson for my clouds, with just a touch of white.

A dark band of cool blue-gray-mauve is brushed across the still-wet board. Then Gerry feathers out the wash, moving it upward into the sky, guiding the colors so they blend softly. Beneath the clouds, he lays in an orange glow near the sun.

G.M. — Since the board is fairly dry here, I'll hit the mountains now. I don't want them bleeding into the sky.

He brushes in the same alizarin/indigo mixture, blending in yellow/orange where the sun flare will be.

2

Establishing the value range

The board now dry, Gerry strengthens the distant mountains with varied tones of indigo/alizarin and softens the shading around the sun flare.

G.M. — I'm mainly interested in establishing my values now. I'll add raw sienna to my yellow, bringing the sky tone down into the ground, to set up those values. Firelight will warm the meadow at right, so that area will be even warmer.

Raw umber and Winsor blue are mixed to create a muted green, with which Gerry begins to build tree masses.

G.M. — I start from the bottoms and brush upward, trying to stay out of the sky area as much as possible.

Waiting for the foreground to dry, he stands back and evaluates the emerging value pattern. Deciding that the sky should be darker, he re-wets the entire area, then adds darker values to the cloud mass, softening edges and building texture.

The Fan Brush
Gerry's tool-of-choice

By the time *After the Storm* is completed, fan brushes will have done about 75 percent of the work.

Above are three of Gerry's current favorites. At left is a new brush, barely broken in. He has trimmed its corners and cut some of the bristles away, leaving irregular clumps. Paint will be forced into the ferrule and allowed to dry there, further stiffening the bristles. The brush at center is his current favorite. Notice how short the bristles have been trimmed along one side. The brush at right is well worn but still being used.

I'm amazed at the many ways Gerry uses the fan brush: Bristles placed parallel to the surface and patted against the board, it creates tufts of grass. Held vertically and flicked right or left, it creates pine boughs. Flicked vertically, it depicts shaggy tree trunks. Held diagonally and dabbed, it creates convincing textures in tree masses.

Developing the tree masses

Returning his board to the vertical position, Gerry continues to develop the painting.

G.M. — I try to take something I've seen, something I've felt, and build on it. In any painting, all you have is story and mood. Detail is not that important. I want to establish my story and mood right off.

Working with his fan brush, Gerry begins developing tree patterns. He adds texture to the distant field, softening its edge at the waterline. Trees are gradually extended upward into the cloud mass, branches feathered out, trunks roughed in.

G.M. — What I'm really doing is developing patterns and dark values around the center of interest. At this point, I'm kind of sneaking up on the height of these trees. They may go a lot higher, but I want to see how everything works before I go further.

Some artists try to make people believe that every brushstroke they put down is right. That's one of the misconceptions people have about painting, and it's the wrong message to communicate to the art student. A lot of time goes into trying something and seeing if it works. If it does, I build on that. If not, I can usually back out of it.

Textures and patterns

Gerry adds white to his green mix and begins stippling in tree texture.

G.M. — I'll highlight the left sides of these trees because they're catching sunlight, and go a little cooler on the shadow side. Chromium oxide for this gives me a neat green. I add a touch of white for a cold shadow tone.

Textures in the foreground meadow are rapidly created

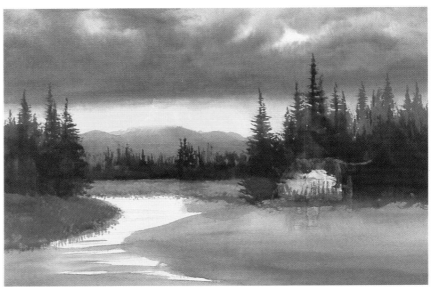

3

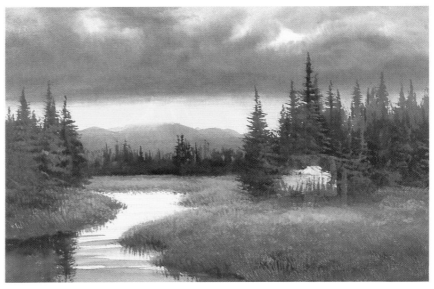

4

with the fan brush — held flat and patted, held upright and flicked vertically. At lower right, the tone goes darker, with Winsor blue, burnt sienna and purple added for variety. Some white in each wash lends opacity.

G.M. — I'm also trying to set up light patterns. As light radiates outward from the sun, it hits the grasses and trees.

Making it look real

Gerry is working on tree masses now: building values and contrasts, adding texture, adjusting colors, and continually evaluating as shifting values bring some areas forward and drop others back. He's still using his fan brush almost exclusively.

Trees are brought closer to the foreground by lowering their bases. The distant meadow is lightened.

G.M. — I'm trying to get light coming through the trees without putting in too much detail back there.

Dots of light below the tree at left add depth. Water reflections are developed using cloud color. The water's edge is defined.

The center of interest

Carefully, Gerry lifts out the masking on the sun and the chuck wagon grouping.

Since most of the pencil lines have come away with the masking, he restates them and then immediately begins painting.

G.M. — I'll add my washes quickly, so the abrupt value change of the white board doesn't disrupt my thinking.

Colors are blocked in with a no. 4 sable round.

G.M. — Now that I see it, I don't know if I like the chuck wagon canopy this way. It's an ugly shape.

He carefully changes it, evaluates, then changes it further. Satisfied, finally, he goes on to carefully refine the wheels, barrel and other details.

G.M. — I try to stay with middle values until the end, when I'll hit the high notes.

Shadows and grasses anchor the wagon, and finally the two figures, a bedroll and the campfire are laid in.

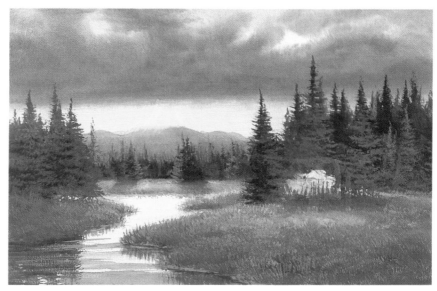

5

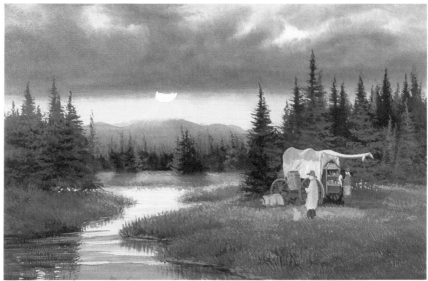

6

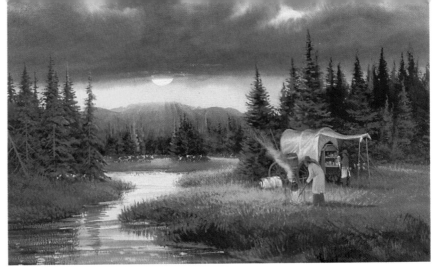

7

Bringing it together

Gerry continues to work on the chuck wagon grouping, refining details, trying different variations on the figure at right, tying the grouping to the surrounding values.

G.M. — If I'm not careful now, I'll lose touch with the painting. I need to finish something, to pull it together.

A plume of smoke is dabbed in with diluted white.

G.M. — The grouping is getting more finished, but I still have to lighten and darken areas around it to tie it into the background.

The main tree masses are lightened with texture and highlighting. The wagon canopy becomes darker. Areas in and around the grouping are adjusted until Gerry is satisfied with their relationships. Every so often, he returns to work on the meadow, deliberately distancing himself from the grouping. Lightening the foreground, he finds, helps integrate the grouping into the rest of the painting.

Burnt sienna/burnt umber cows appear in the distant meadow, overlaid with spots of warmed white. The sun-orange clouds are completed, and the sun itself is warmed very slightly with yellow/white. That same wash is used to create sun rays across the mountain rim.

G.M. — To me, everything up to now has been middle tones. I wait for the end to add my light values. They're the excitement.

The Color Dynamic for *After the Storm*

This is a strongly analogous color scheme, running from yellow/orange through blue/green. A large area of slate blue/violet offers relief, and there's just a touch of complementary contrast with red.

The distant meadow is lightened considerably, giving a lift to the whole area. Further highlights are added to the trees. Grayed-green verticals form tree trunks. For several minutes Gerry works intensely on the trees to bring them to completion.

G.M. — This figure in the foreground bothers me. He's too stiff, and he's standing just like the figure behind him. Let's get rid of him.

In a moment the figure is washed out. Gerry repaints the wagon where he stood. Then, with opaque color, he creates a completely new figure, which this time bends over the fire.

G.M. — I need to focus the foreground light on the fire.

Burnt sienna and umber tones darken the right foreground considerably. The effect is a lightening of the meadow behind it.

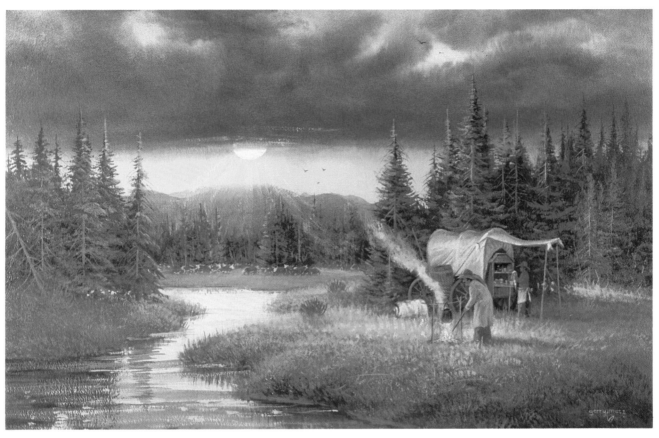

The finished painting

Bringing the painting to completion, Gerry restores the grass textures to the foreground, further lightens the trees at right, and separates them from those behind the grouping with a startling streak of sunlight. Cool backlighting is added to the yellow slicker, and shadows and details are finally adjusted.

After the Storm
Gerry Metz
Opaque watercolor
15" × 22"

One more step

When the painting is thoroughly dry, Gerry steps outdoors and seals its surface by carefully applying four thin coats of Krylon Crystal Clear acrylic spray.

G.M. – This keeps the acrylic varnish from smearing my paint layer.

When the Krylon has dried odorless, Gerry brushes a single coat of acrylic gloss varnish across his painting, sighting against the light to catch missed areas.

G.M. – This brings back the intensity of the colors and gives me a hard, durable surface. I always finish my paintings like this now, and I frame them like oils. I prefer not to use glass because of the glare, and my collectors have come to expect this kind of finish on my work.

Winter Camp
Gerry Metz
Opaque watercolor
40" × 60"
Collection of Larry
Schreibman

The wonderfully frigid atmosphere that
Gerry Metz has created in his painting of
mountain men trekking through the
Grand Tetons results from several paint-
erly devices:

First, of course, is the crisp, visual ren-
dering of a cold, snowy landscape—snow-
shrouded trees, blustery sky and late sun-
light offering little warmth.

Second, the artist's choice of colors
and the way he has muted them as they
recede in the distance emphasize the cold-
ness of the environment.

But the coldness of the scene becomes
meaningful only when it is opposed to the
warmth of the figures and the horse. It is
that warmth that makes everything else
look so cold, and conversely, it is the cold-
ness of the background that emphasizes
their warmth.

Finally, notice the golden aspens in the
background. They help to put the figures
into the landscape by bringing just
enough warm color to them. Lacking that
warm note in this cold background, the
figures might well look "pasted on."

Chapter Nine
Color Harmonies Create a City Mood

Rainy Day
Joe Abbrescia
Oil
20″ × 16″

A warmly harmonious city scene, this Manhattan moment is based upon an orange/blue harmony. These two colors have been mixed to create the neutral hues. Warm tones range from yellow to red, analogous with the dominant orange.

Reflected light in a rain-washed street is a wonderful device for distributing color.

Joe Abbrescia paints a cityscape

Harmonious color: It's easy to define, difficult to describe. You usually know it when you see it: The painting is, well, right. Its colors look, somehow, visually satisfying, inevitable. But what is color harmony? And how can you achieve it in your own work?

Joe Abbrescia, a talented painter who for many years ran his own art school in Chicago, illustrates his pathways to color harmony as he paints this chapter's demonstration, *Morning Light*. Though he has chosen to evoke a city mood, his approach is readily adaptable to many painting problems, as you'll see in his other paintings in this book.

Dividing his time between Arizona and Montana, native Chicagoan Joe Abbrescia still loves the feeling of a big city, still welcomes the opportunity to head for some distant metropolis to fill his eyes, and his canvases, with its unique sights and impressions.

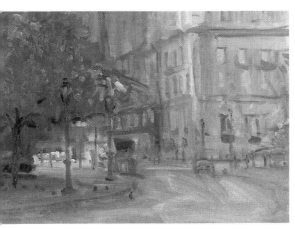

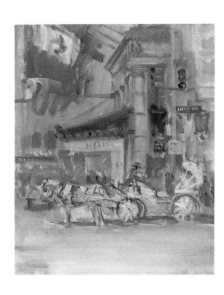

Oil sketches done on location during a recent New York trip were the basis for this quintessential Manhattan scene. Across from the famed Plaza Hotel last summer, amid dashing pedestrians, ogling tourists and marauding pigeons, Joe Abbrescia set up his half-width French easel and painted two oil studies on 12″ × 16″ canvas-covered Gatorfoam panels. The studies became the inspiration for *Morning Light*.

Getting started

J.A. — I'm working on quarter-inch Masonite primed with three coats of gesso. Sometimes I do a thumbnail sketch to establish my composition. But when I have a clear concept, I'll get right to it.

To establish my color harmonies, I'll tone the panel with a neutral mix of my key colors, alizarin crimson and viridian (adding a touch of cadmium red to avoid going too purple).

The mix, liberally thinned with turpentine, is brushed over the entire surface, then wiped back to a more-or-less even, cool gray.

Joe picks up a small bristle brush and begins sketching in contours of carriage, flags and buildings.

J.A. — The early stages of a painting are like beginning a conversation. You're not sure where the dialogue is headed, so your statements are vague. Later, as you focus in, you can begin to refine your approach. But too definite a statement at the outset can be difficult to retract.

After dipping his brush in solvent, he lifts out two dots that will become the traffic signal, and the horizontal band that will become a streak of sunlight.

J.A. — I have to establish my concept at this stage. I know I can't focus on everything. What's important is the color of the flags, the morning light and the carriage.

1

2

3

Establishing concept with value and color

Bold slashes of cadmium red are painted into the flag mass and traffic light.

J.A. – While I'm trying to get a feeling for the color, I am also starting to key my values.

He wipes out more color along the sunlit streak.

J.A. – Once the concept is clear in my mind, I'm on my way.

He wipes away some of the red in the flags, leaving one segment white, brushes viridian into another, then wipes that partly out. Then he keys his lightest value, the sunlit streak, with opaque white. The darkest darks, carriage and driver, are roughly stated in a viridian-alizarin mix. Midtones are scrubbed into horse, carriage and shadows.

J.A. – I'm using turpentine washes to set up my values; I'm not rushing to get into opaque color.

Darker values at left center sil- *houette the horse. Joe goes in very dark, then wipes back, smearing pigment upward along both sides of the flag. Linear strokes are added for the light pole and building details.*

Defining the composition

As Joe mixes his colors, I note that each invariably begins with alizarin and viridian. When he has mixed these to his satisfaction, he adds a touch of cadmium red to warm them, or even an earth tone. This process, he explains, is the basis of his color harmonies. (Examine the color dynamic on page 86 to see how these dominant hues define this painting.)

He begins to define background architectural details in warm tones, edging toward brown, then turns his attention to the sunlit streak.

J.A. – My dominant color will be red, so I'll mix yellow and white with alizarin to produce a low-chroma orange that still looks bright. I'll carry the highlight to the right, through the wheels, adding a touch of alizarin as it moves behind. That reduces its intensity, so it will look like light showing through, not pasted on.

In nature, I find that light steps down in both value and hue as it moves away from the source. Toward the center of the light the hue is red-orange. As it moves away, it changes toward red, then red-purple, and becomes darker and lower in chroma. If you can create these halo effects, the light you paint will be believable and not just look pasted on.

He continues building values in the background, scrubbing neutral tones into the under-painting.

A dark mass forms the hotel canopy. Lighter gray is scrubbed in below and around it, pushing the background back and bringing the horse forward.

4

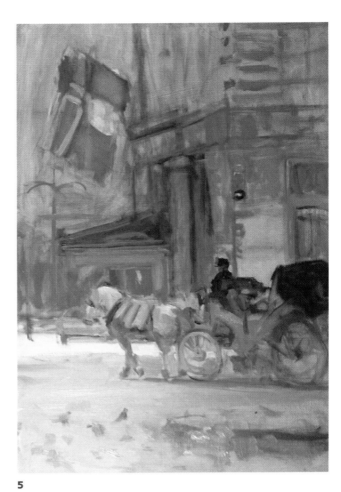

5

Establishing believability

J.A. — We all know what a painting is supposed to look like when it's finished. The problem is understanding what it's supposed to look like along the way. At this stage it's lacking a lot of the information that will make it believable. My method is to step back far enough so I couldn't see those details even if they were there. If the painting looks believable from back there, then it's on the right track. As I put more information in, I'll be able to stand a little closer. When I'm able to accept the painting's believability at the normal viewing distance, then I know it's finished.

Tone and value are still being adjusted as warm-gray washes are added to background and foreground.

The driver, passenger and other details are defined now, and more shadows and high-lights are added to both horse and carriage.

J.A. — I want to establish the believability of the carriage before I deal much with the background.

He continues defining harness, mane, shape. The taxi begins to appear.

J.A. — The taxicab is a great way to break up the light as it moves across the picture.

Bringing it together

J.A. — Now that I've added detail to the carriage, the rest of the painting appears incomplete, so I have to bring everything else up.

He adds linear details to the architecture and builds up the foreground shadow areas.

J.A. — I'm working with color harmony here, not with what I believe reality to be. That's an important distinction. I have to stay within my parameters — my two colors — to maintain color harmony.

He lightens around the red traffic signal, blurring its edges, then wipes out its center almost to white. The same is done with Winsor green in the green signal. A touch of yellow in their centers, and they suddenly light up!

J.A. — The traffic lights will be my strongest chromas, and for that reason I had to establish them before working on the flags.

He works on the flags, then returns to detail the building facade around the streetlight, hotel canopy, foreground and carriage.

J.A. — Notice the halation where the legs of the horse meet the light? I could just blend the two, but by pushing the boundary toward red, I create a vibration that's more exciting, more believable. The Impressionists used that a lot.

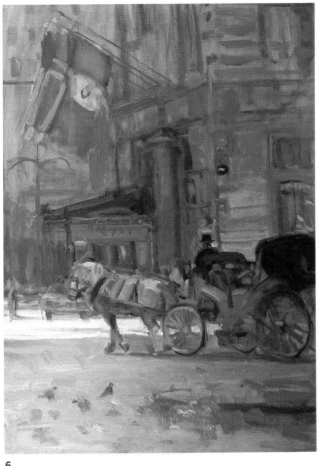

6

7

Closing in on the finish

Joe is refining details of the horse and carriage now, bringing them into sharper focus without overstating details. Darker values in the left background bring the taxicab forward and add depth beneath the hotel canopy.

J.A. — I try not to ask myself what's wrong with a painting I'm working on. I look for what's right and build on that. I check my concept and see what still needs to be realized—not "finished," which refers to the painting, but "realized," which connects with the concept.

In this painting I want you to look at the carriage, so everything else has to support that. If I look at the carriage and see the adjacent background, something is wrong.

Too much detail will do that. If you hold onto your concept, you'll begin to see what doesn't belong.

As he works on the carriage, he begins to focus on the ground just below it. It says to him, "touch me here." He adds a few flecks of color, breaking up the area, helping his eye bridge the space between carriage and foreground.

Adjusting hues

Joe examines his painting under warm photographic lights and decides that it has turned too cool. To correct that, he mixes Indian yellow with glazing medium, tests this on a small area, then lightly glazes over most of the background with a wide, flat sable brush.

Satisfied, he returns to the background, adding a suggestion of distant windows.

J.A. — Now you don't see that area as a space.

Touches of light add dimension to the extreme foreground. A smear of light behind the driver's neck focuses attention on him, separating him from the background.

8

Checking patterns of light, dark and color

J.A. — Three elements are very critical at the end of my painting: the way the light pattern travels, the way the dark pattern travels, and the way the bright colors travel. Focusing on color harmonies, the orchestral analogy is very appropriate: Lights in a painting are like trumpets; they can dance around and sparkle through the composition. Darks are like the bass notes. They establish the rhythms. Color is the melody. So I check each and start to correct.

First the light pattern: I want the light to travel both horizontally and vertically.

More light is added below the carriage to carry the sunlit streak horizontally. Lightening the traffic-signal pole moves the light pattern vertically, as do brushstrokes to the left of the driver's head.

Squinting to perceive the dark pattern, he darkens carriage, harness and wheels, then the background to their left.

J.A. — I'll look at color now. I want your eye to follow the pattern of reds through the painting, from flags to stoplight, and from flags downward to the sunlit streak.

He brushes red into the architectural details of the hotel, into the red lights at the corners of the hotel canopy, and into the left background.

The Color Dynamic for *Morning Light*

A strongly red/green complementary scheme, with just a few accents, is the basis of the integrity of this composition.

The finished painting

J.A. — The painting is predominantly gray, with bright color opposition. My color harmonies are based on dominant color (red) and opposition (green), with all other colors kept close.

In order for your colors to be harmonious, you want to keep them analogous (very close together) or complementary (very far apart). When some are close and others are spread, the eye becomes confused, because it can't understand what it's seeing. A statement must be made.

The touches of violet and yellow you see in this painting are my "discords." They do an important job here by serving as a bridge between red and green, filling the gaps without upsetting the harmony.

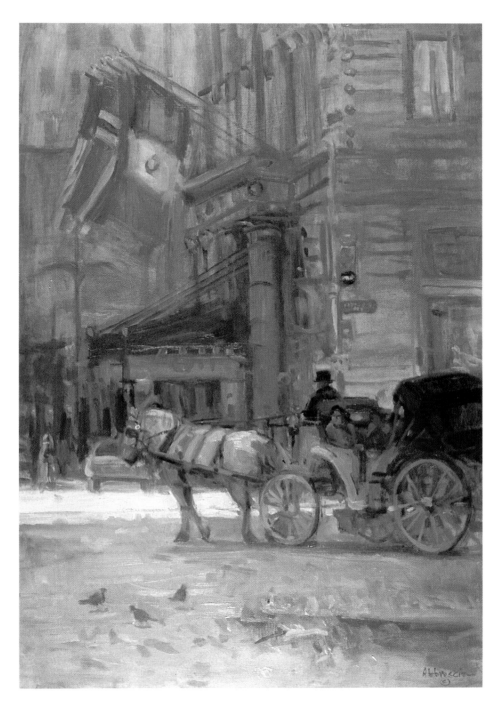

Morning Light
Joe Abbrescia
Oil on gesso panel
24" × 16"

Saturday Morning, Venice
Joe Abbrescia
Oil
40" × 30"

This subject utilizes a strong red-blue/green color harmony. Though the red dominates, the strong blues and blue/purples in the painting add powerful color contrasts.

When using high-chroma color to portray a subject that is really bright, strong value contrasts are also needed to support it. Here the artist has used both pure white and dense black.

Bow Bridge
Joe Abbrescia
Oil
16" × 20"

This sensitive scene in New York's Central Park is successful in evoking both city and autumn moods.

The harmonies in this painting are based on blue and orange, with warmer colors dominant. Accent colors are to either side of the dominant hue. The small touch of green, echoed in the distance, is a discord that helps bring the composition to life.

Day's End
Joe Abbrescia
Oil
30" × 40"

This is a composition in yellow/orange and blue, with warm hues dominant. The foreground blue is the opposition color. Variations on the dominant color run almost entirely toward red.

Note how effective the violet accents are in this painting. Violet is the discord to this orange-blue harmony.

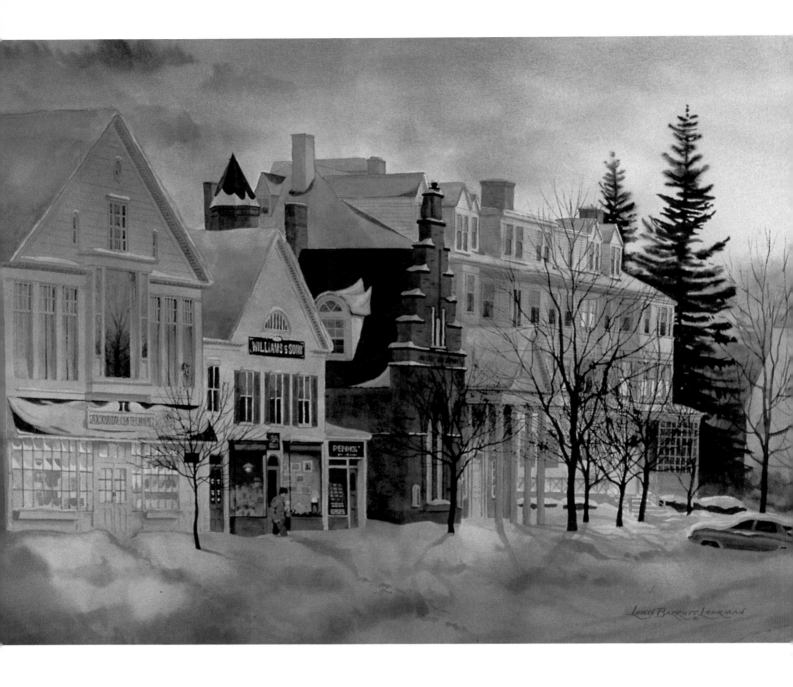

Chapter Ten

Evoking the Mystery of Night With Color

Lew Lehrman paints a nocturne

There is an aspect of the night that has fascinated me since the age of eleven, when my parents put me aboard the Wolverine Limited at New York's Grand Central Station to spend a month with my aunt and uncle in Michigan. I remember awakening before dawn in my darkened Pullman berth and raising the shade to watch the Midwestern countryside glide silently by. Deep blue predawn darkness, warm golden light in lonely farmhouse windows—the image has remained with me all these years, as fresh and stirring as that early morning so many years ago.

Perhaps this is why I am so strongly drawn to painting night scenes. That feeling I try to evoke—warm light in a cold world—seems to strike a responsive chord with many people who see my work. Night scenes are among my most popular subjects.

The physiology of sight makes painting the night an essentially monochromatic process. Low light levels cause the eye to perceive value at the expense of color. Thus those areas of the scene that are in darkness exhibit little color, and what color is visible is quite neutral in intensity.

The dramatic difference between the dark, monochromatic neutrals of the night and the high key, high chroma of the light effortlessly establishes the composition's color contrast, value contrast and center of interest.

Selecting the subject

Have you ever tried plein air painting at night? I have. It doesn't work! The very darkness I longed to observe and portray denied me the working light to paint by. When I stood where there was light, my night vision disappeared. For me, the most practical way to paint a night scene is to observe it, make sketches and notations, then paint it in my studio. Or I'll work from photographs.

Almost any daytime sketch or photo can be painted as a night scene by approaching the subject logically. For the demonstration painting in this chapter, *Finishing Our Snowman*, I began with a composite shot of our own Colonial-era home in Massachusetts, photographed on a bright winter day.

Once my subject is chosen, I decide how the scene will be lit. I will place the moon behind the house, throwing its near side into shadow to afford maximum contrast against the lighted windows. I'll place the children-and-snowman grouping against deep shadows and nearly black trees and shrubs so they'll stand out even in the darkness. A quick value sketch establishes my composition, and I am ready to begin.

Getting started

I begin my drawing on a stretched sheet of Arches 140-lb. cold-press watercolor paper. My first sketch is as light as possible. Only my final lines will be carefully drawn and strongly stated, to come up through the deep washes to follow. (When preparing to lay large, dense washes, it's essential to avoid *any* erasures. The slightest abrasion causes the paper to absorb pigment unevenly.)

Liquid frisket is used to mask the moon and some windows. (Deciding which windows to illuminate

1

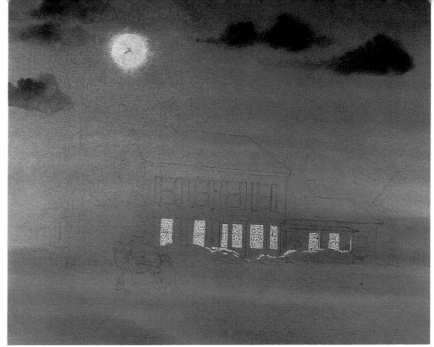

2

is part of the storytelling aspect of the painting.) Knowing that light reflections will be strongest below the illuminated windows on the snow-capped hedges, I mask these edges as well.

The initial wash establishes the night

While the masking fluid dries, I set up my palette with fresh, moist Winsor & Newton pigments, essential for the rich, deep values I want.

In a daylight scene, the watercolorist has to preserve whites. In a night scene, with the exception of those already-masked areas, ambient light (moonlight, starlight) on the scene defines its lightest value. This base color has to be fairly dark—perhaps a value 3 or 4 on a scale of 10 where "0" is black. Get it too dark, and the scene absorbs all light, becomes muddy and dies. Too light, and the scene looks like dim daylight!

With my board flat, I wet my sheet from edge to edge and lay in a fairly dense, even French ultramarine/burnt sienna wash, mixed to the cool side of neutral. A few drops of Gum Arabic added to the wash will help keep this layer from lifting when I re-wet it later.

I work this wash horizontally, edge to edge, with broad strokes of my 2-inch sky-wash brush, keeping it darkest at top and bottom. I can manipulate this initial wash without limit, smoothing transitions, darkening, lightening, adjusting color temperature, yet always working over the entire surface, keeping it evenly wet.

When I'm satisfied with the value (bearing in mind how much lighter it will appear when dry), I mix a very dark wash of the same two colors, this time with burnt sienna dominant, and lay in a few dark clouds to feather out on the still-wet sky. Then I leave the whole affair to dry thoroughly.

The French (Ultramarine) Connection

The complementary colors French ultramarine and burnt sienna are the basis of most of my neutrals, particularly in night scenes. By varying the proportions of the two, I can achieve slatey blues, cool grays reminiscent of Payne's gray, perfectly neutral (though still lively) grays, warm grays, and even strong, rich browns. The two colors used full-strength make a velvety, interesting black. No matter how they are mixed, both colors remain present, adding subtle color variations that are always interesting.

To make this neutral blend even more useful, I can add a touch of practically any color to it, to "tilt" it toward that part of the spectrum I want to reach.

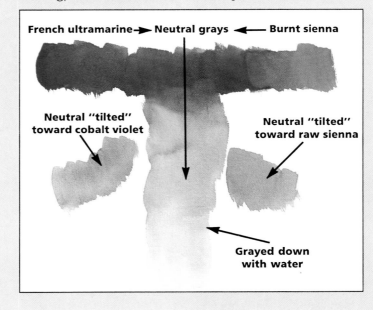

French ultramarine ➤ Neutral grays ◄── Burnt sienna

Neutral "tilted" toward cobalt violet

Neutral "tilted" toward raw sienna

Grayed down with water

Night-dark trees to frame the scene

Preparing now to lay in the background, I use a fine-mist spray of water to re-wet the entire sky area, down to the roof line of house and barn, which I cut in with my 1-inch brush.

A new, dense burnt sienna and French ultramarine wash is now mixed, with burnt sienna dominant. I lay in this wash, working upward from the roof line. The wet background causes the edges of the wash to blur against the sky: fine branches seen at a distance. Touches of brown madder alizarin and cobalt violet are dropped in to add color variation. I also take this opportunity to restate the clouds.

While I'm waiting for this wash to dry, I establish the darkest value in the painting with an evergreen at right, then begin shading the near side of the house.

With the sky again dry, I re-wet and lift some of the pigment around the moon with a small, stiff stencil brush to create a haze effect.

Moonlight and shadows

When everything is thoroughly dry, I strip frisket from the moon, revealing clean, white paper. This will remain my lightest value.

Spraying a fine mist of water over the moon, I lay in a soft-edged cloud.

Moonlight is also defined by the shadows it casts. I begin placing shadows, trying to keep them believable while taking some liberties with the actual geometry involved. I am, after all, painting mood, not reality.

Now I begin to define more of the darkest values, tilting my dark mix with Winsor green for evergreens at the far left and at the corner of the house. I also begin to shadow under the eaves of the house and around the bay window.

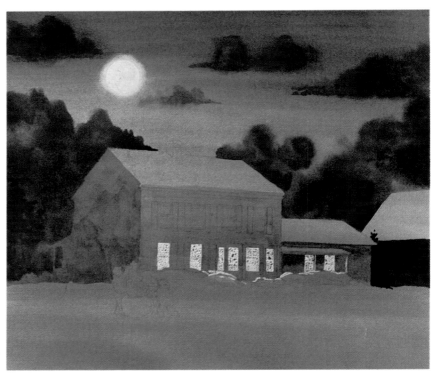

3

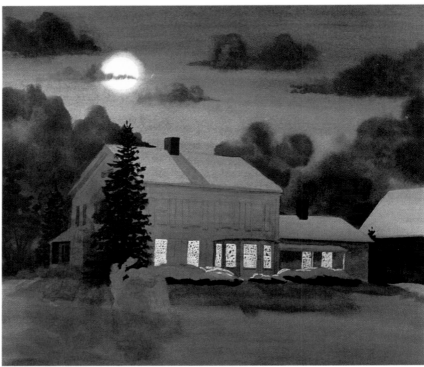

4

Outdoor details

More details are now defined: darkened windows, shutters and so forth. The huge evergreen at left (scaled down considerably from its actual size to appear in better proportion with the house) is laid in. My memory of snow melting away from the chimney provides a way of defining the roof ridge without completely closing it off from the sky.

When the painting is thoroughly dry, I lift off the remaining frisket material, and I'm ready for the fun part!

Turn on the lights!

It's tempting to make all the illuminated windows as bright as possible, but I know that I must establish dominance in one area. I want the bay windows at center to have the strongest emphasis, so that area receives the cleanest, lightest wash of new gamboge (yellow). To either side the wash that fills the windows includes some raw sienna—darker in value, reduced in intensity the farther from the bay windows it appears. At the outermost windows, burnt sienna is added to reduce the light still further. Shades and curtains are indicated with raw sienna, to which some burnt sienna has been added. I'm careful to keep the values light enough to suggest translucency. Finally, dark window mullions are added, and those irregular edges are trimmed up with dark gray.

A word of caution here: It's tempting when doing illuminated windows to include what's inside—furniture, pictures on walls, and so forth. Don't do it! That kind of detail does nothing but reduce the value contrast of the window, greatly reducing the effectiveness of the scene.

For light spill on the snow, I re-wet the area with water spray, then scrub the desired areas with my stencil brush, lifting out most of the night tone with a tissue. While these areas are still wet, a light-yellow wash is laid in.

A secondary center of interest is added now—the red door and the silhouetted figure.

Now I begin on the foreground grouping. Because both the children and snowman are in darkness, the value range for this grouping is narrow, and the colors are subdued. But because in my composition I planned to place the figures against the darkest value masses, they will stand out even within that narrow value range.

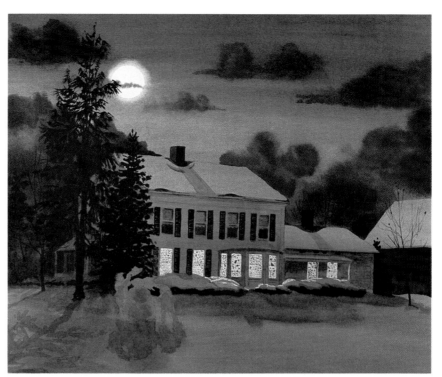

5

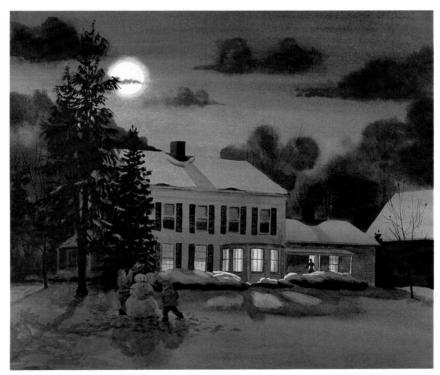

6

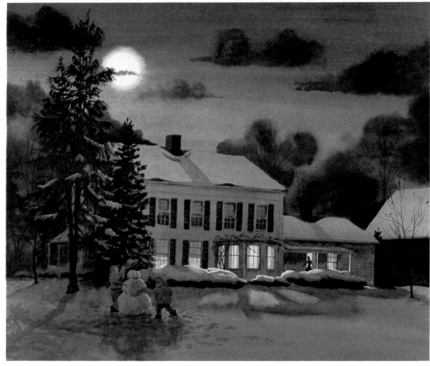

7

Finishing touches

Closing in on the finish now, I add a bit more detail to the house, pick out a few snow-laden branches on the large evergreen at left to separate and bring it forward, and continue to work on the kids and the snowman.

Preparing to add highlights and sparkle, I squeeze a bit of gouache white onto my palette.

A streak of yellow-hued white on the snow at far right separates hedge from house. Cool gray mixed into white is used to rim-light the snowman. As is so often the case, I'm not sure how effective this will be, so I continually evaluate as I go. Liking the way it's working, I tint my white to rim-light the children as well. I like that too. How about snow-laden branches that might be catching light from the moon? Yes! So much of this is based on what one might logically expect to see, in combination with what looks right on the painting.

A plume of smoke from the chimney is created by re-wetting the area with a fine mist of water, lightly scrubbing with a soft brush, and lifting out some color. Sparkles of blued-down white are spattered on the snow. The reflected light on the hedges is softened with white, to which some new gamboge has been added. I stand back to review the piece before adding my signature, and the painting is finished.

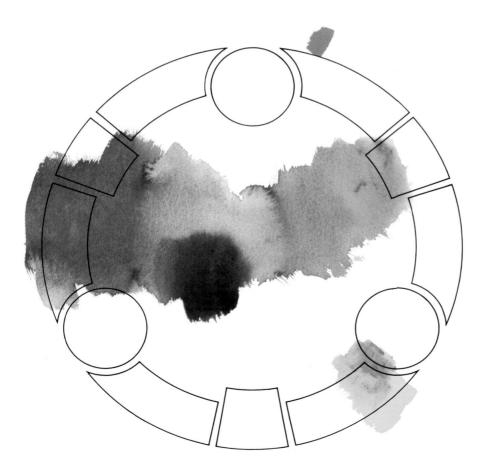

The Color Dynamic for *Finishing Our Snowman*

Nearly monochromatic in appearance, the color dynamic for this painting reveals a narrowly complementary color scheme, revolving around neutral blue and dark brown (burnt orange), which very nearly neutralize each other. High-chroma yellow, at maximum color and value contrast, and a dash of red provide the centers of interest.

**Finishing Our
Snowman**
Lewis Barrett
Lehrman
Watercolor
15″ × 18″

The finished painting

Compositionally, the brilliant light
in the bay window catches the eye
first. Then the figure in the red
doorway. Only then is your eye re-
directed toward the children in the
foreground—a small discovered
surprise.

Snow Fun III
Lewis Barrett
Lehrman
Watercolor
15" × 22"

The lighted windows glow in this snowy, late-afternoon scene because the values around them are far lower than they appear. Dark window frames help emphasize the contrast.

Working from a black-and-white picture, I chose to connote the warmth of the house with a yellowed hue, rather than the cooler color I might normally choose—a decided risk. However, by glazing with neutral blue/gray and shadowing the near side of the house to an even darker value, I was able to maintain ample value- and color-contrast against the warm lighting.

The chilly hues of the wet-in-wet painted background help enhance the effect.

Back Road, Summer Evening
Lewis Barrett
Lehrman
Watercolor
13" × 21"
Collection of Lora
and Eugene Wishod

On this warm, humid evening, one can almost see the countless insects swirling around the streetlight and feel the motionless air in the muggy twilight. To enhance the summery effect, colors were kept warm and relatively high in chroma, using blues, greens and yellows reminiscent of a forest or jungle.

The Diner
Lewis Barrett
Lehrman
Watercolor
25" × 35"

Light of a different sort glows from this painting, another from my "From My Childhood" series. It is the light of a time remembered, of a place remembered, of aromas and sensations impossible to put into words.

An analogous color scheme—green, yellow and orange—sets the mood. Bare, hanging light bulbs, with the detail burned away around them, throw the counterman's face into deep shadow. And what better way to suggest the aromas in an old diner than with the menu items themselves, in ghostly superimposition?

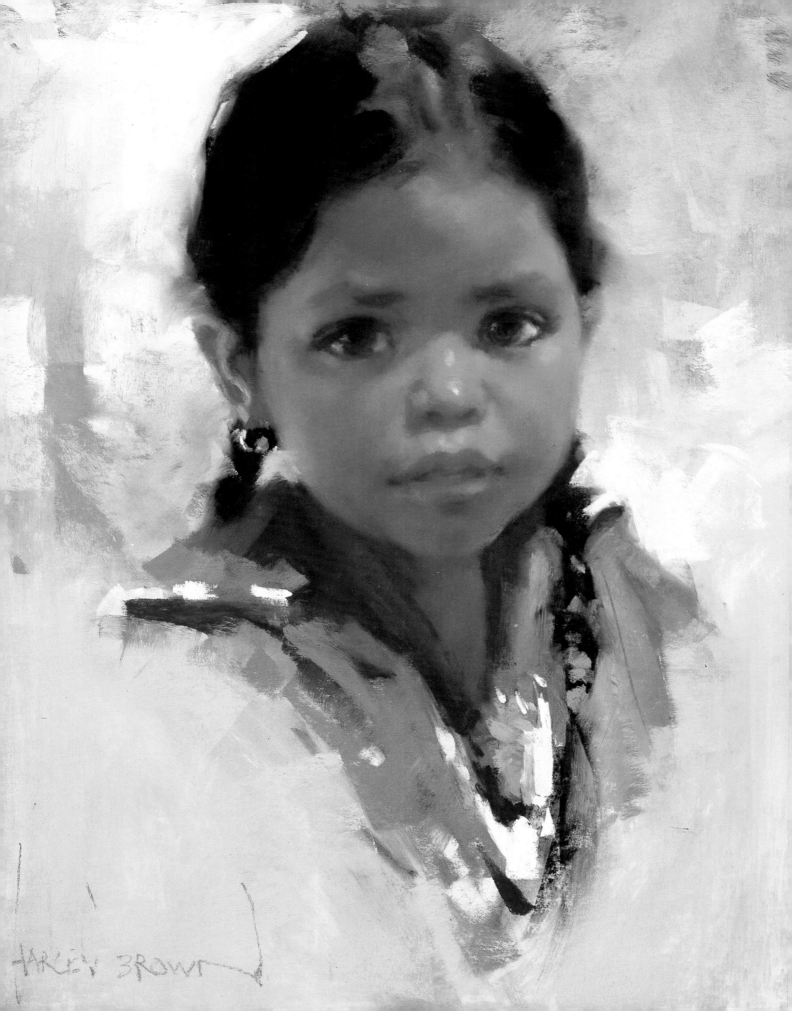

Chapter Eleven
Using Discords for Color Harmony

Harley Brown paints a portrait in pastels

To those who know him through his work, or
through his always-booked workshops at the
Scottsdale Artists' School, Harley Brown is an
acknowledged master of the art of pastel portraiture.
A native of Canada who spends part of his year in
Tucson, Arizona, Harley is an elected member of the
prestigious National Academy of Western Art. A
long, complex and arduous path has led Harley
Brown to his present preeminence in his chosen
discipline, the circumstances of which he shared
with readers in my first book, *Being An Artist*
(North Light Books, 1992).

Harley's use of color in his portraits is always bold,
always energetic. Fleshtones come to life with
unexpected hues. Backgrounds—loose and free—
are playgrounds for the color energies that radiate
from his work.

As we discussed his approach to the subject,
Harley made frequent reference to his use of
"discord" colors to create color harmony, as well as
his reliance on five "principal" colors instead of
three primaries. Later, I traced these concepts to the
Munsell System of Color Notation (see pages 110
and 111).

1

The pose

Preferring to work from life, Harley has booked professional model Beatriz Lafner, a native of Colombia, for this session. Posing in Spanish garb, she is illuminated by warm light from the left, with ambient room light as the only fill.

Harley works from a small pile of Rembrandt, Sennelier and other pastels he has selected from the countless fragments in his trays. I ask how he selected the twenty or thirty he has laid out.

H.B. – There's more reason to this than there might seem. It's important when learning the medium to select and line up the pastels you plan to use. There are cool fleshtones and warm fleshtones, from dark to light. Cooler midtones for shadows.

His paper for this study is Canson's Champagne, a warm, light pastel paper with a slight texture.

H.B. – It's a neutral color that won't dictate what I must do. Sometimes as a challenge I'll choose a dark-toned paper that *does* dictate, forcing me to build *up* to the highlights, *down* to the darks.

To keep his colors pure, he holds a wad of paper towels in his left hand and wipes each pastel before use.

Telling the paper who's in charge

Harley begins scrubbing in seemingly random strokes of raw sienna and umber, breaking up the unmarked purity of the paper.

H.B. – I'm looking at Beatriz, perceiving some of the swoops and swirls I see . . . getting a vague feeling of what's happening. I don't want to build up too much, so I'm alternating strokes of pastel with wiping, using the paper towels I always keep handy.

Out of the scribbles, the dark mass of the model's hair suddenly appears, then the shadows in her eye sockets, the hint of an eye, the left edge of the face.

H.B. – I'm just "mushing in" where certain things go, but with a degree of accuracy, because if I don't get it right now, I'll pay later on.

He suddenly selects yellow-green and jabs a few strokes onto the paper.

L.L. – Where did that come from?

H.B. – I'm thinking of the color contrasts and discords to come. And I wanted to cool that side down.

With great care Harley measures and remeasures his proportions, carefully checking his plumb lines to make sure the vertical alignments are precise.

H.B. – If I first get things where they belong, I won't waste a lot of time later trying to readjust the spacing of the eyes, the length of the nose, and so on.

2

3

The face emerges

The shapes of the eyes are roughed in.

H.B. — I often start with flesh-tones in the eyes; the whites of the eye are not white.

A few strokes of umber outline the jawline. Vague shadow tones begin to define nose, mouth and right jaw, and suddenly the portrait takes life.

Building color contrast and adding discords

Deep brown and black are scrubbed into the hair mass. Rummaging through his Sennelier pastels, Harley finds a rich, warm red to begin the flowers. Throughout this building of values and contrasts, he continually verifies proportions, establishing top of hair, position of flowers and so forth.

H.B. — Bright flowers against dark hair. I like the darks in a portrait to be very dark. That slash of chartreuse and another of lavender will serve as discords.

L.L. — Do you ever use just one discord? Or must you always use both?

H.B. — I find that using one discord almost demands adding the other. But they're best when used in small doses.

Returning to the painting, Harley adds warmth through the center of the face.

H.B. — The faces of most Caucasians have a rosiness across the center — ruddy cheeks, red nose, alizarin-crimson ears.

I mention that the model's personality already seems to be emerging from Harley's tangled strokes of color.

H.B. — I think that comes down to a keen eye and a steady hand, but mainly from working toward preliminary accuracy.

4

5

Establishing the features

Harley smudges in the lips with little regard to precision, then begins to define them more carefully.

H.B. — Lips are an elusive feature. The left side here will appear smaller than the right since we're not viewing the lips straight on. When it comes to features, you should spend more time looking than painting.

Harley lays in the right side facial shadows, darkening the core of the shadow closest to the illuminated side; then he goes on to lay in the left neckline, extending the hair mass downward. Intense black in the hair mass establishes the left jawline, as does a softer black along the right.

Adjusting colors

H.B. — A good rule of thumb is that parts of the face that turn away from the viewer should be cooled

slightly. So I'm adding just a touch of green to the left cheek. (I should add, though, that most of the rules I state, I end up breaking all the time.)

When working on the nose, you have to understand the foreshortening that goes on. The shadow is so important.

Now Harley's focus shifts to the background, as he decides to explore what's happening around the figure and to expand the focus of the picture. Cool violet is stroked in at right, augmenting the discord.

Strokes of shadowed red and light pink are added to and around the flower in Beatriz's hair, adding a flamboyant touch to the strong color contrast.

H.B. — I'll keep the background quite simple, warming it up but letting some of the purple come through.

Harley adds yellow ochre across the top and down the left

side. A few strokes of light blue/ green (complementary, I note, to the intense red) cool it slightly. Throughout this process, he continually returns to eyes, cheeks, nose and mouth to adjust and refine shapes.

H.B. — It's important that the nose shadow be both clean and correct since it does so much to describe the shape.

6

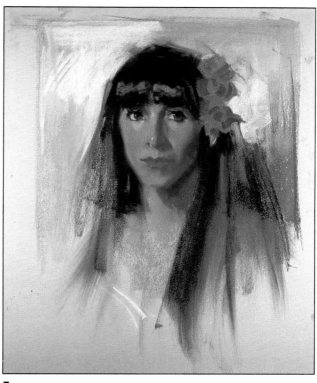

7

Completing the value range

Harley now spends time defining the expression of the eyes as precisely as possible. Then he begins to gradually expand the portrait downward from the head. Veil and upper chest tones are laid in and blended. Shadowed flesh-tones show through the veil at right.

H.B. – I'm saving my darkest darks for the center of the picture. I don't want them popping up everywhere.

A seemingly insignificant stroke of white on the chest triggers a sudden realization. Harley vigorously slashes in an area of pure white at top left. The transformation is instantaneous: The fleshtones appear noticeably darker as the full value range of the composition is established.

H.B. – Starting with toned paper, I had nothing to base my values on.

I realized that I needed to establish a lightest light. Most of the time, I put in this white at the very beginning.

Bringing it together

White tones are brought around to the right side to echo the main white area. Ochres and violets are added to the background, and dark accents are placed in the roses. A few tiny flecks of green around the eyes bring them to life.

H.B. – These color accents localize the eyes, focusing attention on them instead of merely running fleshtones all the way through. Especially with women I like the eyes a bit cooler. Artistically it enhances them.

Harley works on the shadows of the jaw and adds a touch of cadmium red to pick up the reflected color of the flowers on the cheekbone.

H.B. – Shadows don't like detail or texture or hard edges or intense colors.

Very light pink is used to add reflective highlights in the eyes. A touch of purple is added below the right eye and to the left cheek as Harley discerns coolness there.

H.B. – I'll work lots of subtle colors into the fleshtones that you'll probably never notice. But they do add life and interest.

Focusing

The earth tones of the background are blended and neutralized with a light blue-green. An intense green is added to the stem of the roses.

H.B. — This is one of the most important color areas in the painting. It's a counterpoint to the red, and it will be the strongest cool color in the painting, to draw the eye immediately.

Harley warms the hair in places, darkening it where it is adjacent to the roses. The mass of shadowed hair from the left of the rose to the right of the chin will be the darkest mass in the painting. Soft highlights are added to the lips.

H.B. — You want to keep areas like the lips simple, in the red fam-

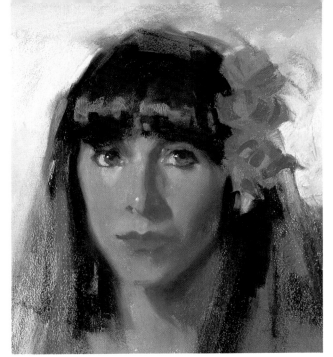

8

ily, never siennas. Avoid placing a line between the upper and lower lips. I try to lose that edge. The red of the lower lip bleeds just a bit into the flesh, and a touch of green cools the chin to the left of the mouth, where it turns away.

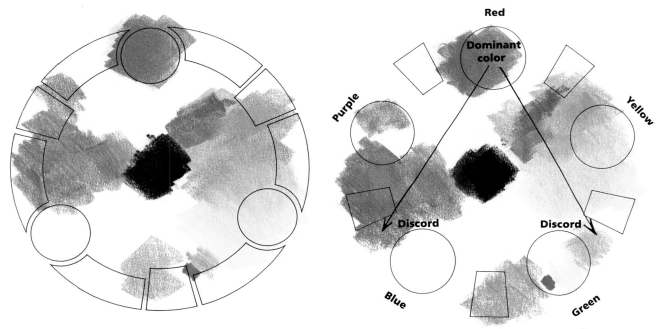

Triadic-based **Munsell-based**

The Color Dynamics for *Beatriz*

Two color dynamics are shown for this work. The triadic version suggests a warm-hued analogous color scheme, with violet as the complementary contrast.

Note how the Munsell-based color dynamic alters the color positions significantly. Now visible is the equilateral triangle, which, with red as the dominant hue, defines blue/violet and yellow/green as the discord colors.

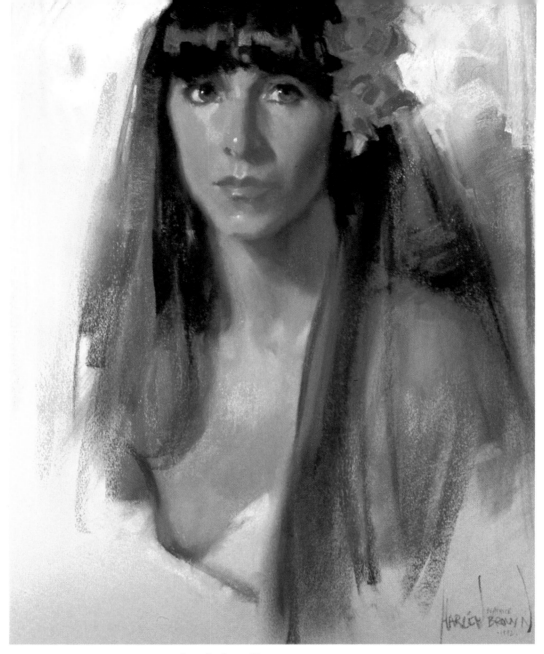

Beatriz
Harley Brown
Pastel
20" × 16"

Final details

*Hair and veil at left are softened
and blended with the shoulder,
as Harley turns his attention to
neck and chest.*

H.B. — I won't have too much de-
tail in the neck, but it has to be
right. I'll simplify dramatically.

This painting is in the warm fam-
ily . . . reds, with grays and ochres,
and such. That warmth has to be
offset by cools: in this case, blue-
greens and lime greens, some of
the grayed purples in the veil, and
the grayed-blue reflections in her
hair. The purple and lime green dis-
cords enhance each other. The
strong chroma of the red flowers is

complemented with the intensely
green stem.

*Harley softens edges with the
palm of his hand. He stands back
to evaluate, checking for errors
by viewing the reversed painting
in a pocket mirror. Is it finished?
Harley thinks so; he signs it but
then fusses a bit more with it.*

H.B. — The worst thing I could do
would be to peck away at it. I
wanted to soften a few edges so
they don't catch your eye. I'm not
looking for perfection. Working
from life, you have the added bonus
of limited time. So you want to
stop. If you keep putting in things
later, I guarantee they'll be wrong.

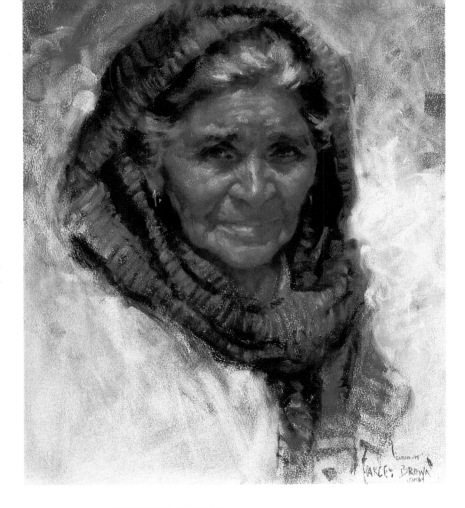

Guadalupe
Harley Brown
Pastel
20″ × 15″

''I found it interesting to keep her face warm, surrounding it by the cool hues of her rebosa, and a rather cool background,'' says the artist. ''The circular shape of her face is made even more interesting by surrounding it with the interesting shape of the headdress.''

In terms of the colors in *Guadalupe*, there are virtually only two: high-chroma orange/reds, and low-chroma blues.

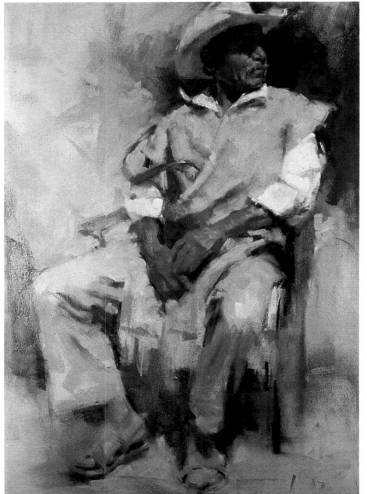

Celestino
Harley Brown
Pastel
23″ × 15½″

The cool, high-value red (pink, really) of this Mexican farmer's serape sets the tone for this painting. Note the way lime green tones have been worked into that dominant pink, especially in the pants and across his chest.

A deep, cold purple/blue, and red in the top right background, repeated in the serape fringe, make the only strong color statements. The deep value of the background at top right highlights the sunlit portions of the subject's face and provides visual continuity with its shadowed areas. A second result of placing this strong background at top right is to pull the head (and thus the entire figure) forward as the dark background recedes.

The light turquoise at left and right center serves as a strong complementary color contrast to the dominant red of the painting. The blue/purple and the lime green are discords.

After the Rehearsal

Harley Brown
Pastel
22" × 16"

The model had just come in from a rehearsal, her makeup wet and running from rain, and she posed for an abbreviated session in this local sketch class.

With only ninety minutes, there was little time for planning. The color play in the background came, according to the artist, strictly from his subconscious, not according to any of the rules or principles he normally might follow.

The dominant hue is from yellow toward fleshtones and red, but not strongly so. In fact, most of the colors of the spectrum appear here. Strangely enough, the composition works.

If there is anything to be learned from this picture, it is that one needn't always use color by the rules. At times, it is okay to let your intuition take over and guide your color selection.

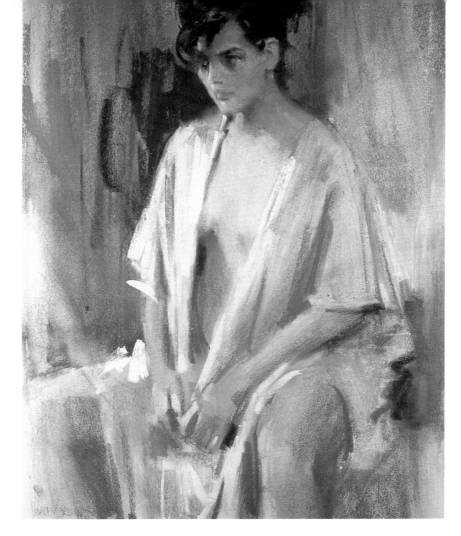

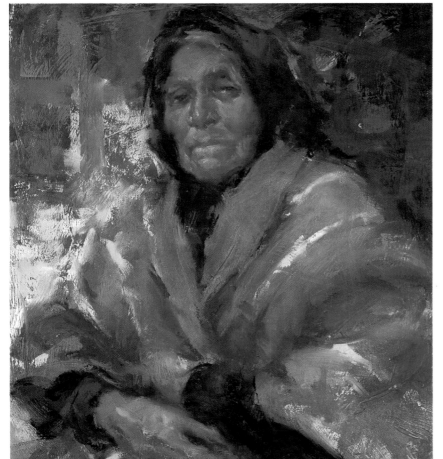

Mama Sarah

Harley Brown
Pastel on gesso panel
12" × 10"
Collection of Tom Hill

The dominant colors in this work are obvious. The reds go "all out"! The purples and blues are quite a necessary relief from the heat of the earth tones and reds.

"I was after a certain point of view with this small painting," says Harley. "Sarah has the appearance of being in full control, even in a passive way. All the dark tones (save the white lines in her shawl) finally give way to the burst of white at middle left. A strange composition, but it seemed to work.

"This is a fine example of 'going for broke' . . . with bravado! Chancing it. Risking. But it must be honest in nature or the result won't be convincing."

Another Way to Look at Color: The Munsell System

Though the system based on three primary colors is widely accepted and widely used by artists, there are others for whom the triadic theory just doesn't work. The early developers of color printing, for example, realized they could not combine the triadic primaries on a printed page to achieve a full spectrum of colors. The Munsell Color Notation System was created to more scientifically deal with color and meet these kinds of needs.

Conceived in the early part of this century by A.H. Munsell, the system established five "principal" colors—red, yellow, green, blue and purple—laid out at equidistant points around the color wheel. Printers found the pigments that would reproduce the fullest range

of colors lay in an equilateral triangle on the Munsell wheel: *magenta*, a color red that's similar to rose madder; *yellow*; and *cyan*, which is similar to cerulean blue.

Additionally, Munsell introduced a notation system identifying a color in terms of its three attributes: *hue*, *value* and *chroma*. Hue is indicated by designated letters or by numerals from 10 to 100 around the color wheel (see the figure below, left). Value is measured on a scale of 0 (black) to 10 (white). Chroma is measured on a scale of 0 (neutral gray) to a number representing the color's maximum departure from a neutral gray of the same value. This might be 10, 12, 14 or more (see the figure below).

The notation for a sample of vermilion, for instance, might be "R5/14," indicating a red (R) of middle value (5) and high chroma (14). An even more precise description might include the color number (8R5/14, for example, indicating a red that's a little more toward yellow).

The Munsell Color Notation System has proven invaluable in standardizing and systematizing color and is widely employed by graphic and industrial designers, scientists, engineers, printers, and others who require precise, reproducible color standards. As one might expect, however, most artists who utilize the Munsell system do so in a more informal, intuitive manner.

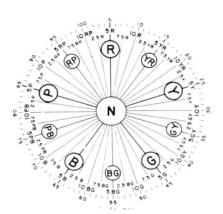

Standard Munsell hues are arranged around a circle divided into 100 segments.

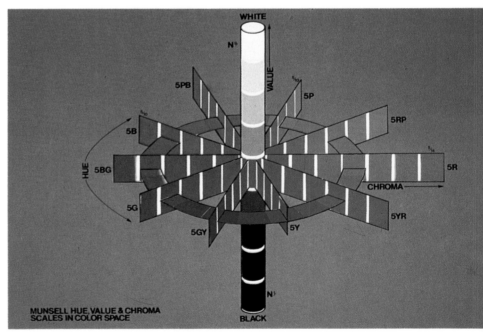

Hue, value and chroma for colors at value 5. Note that red is most intense at this value, while yellow at value 5 is quite muddy. Yellow, a light color, achieves its maximum chroma at value 9.

Courtesy of Macbeth, Div. of Kollmorgen, Munsell Color, P.O. Box 230, Newburgh, NY 12551-0230.

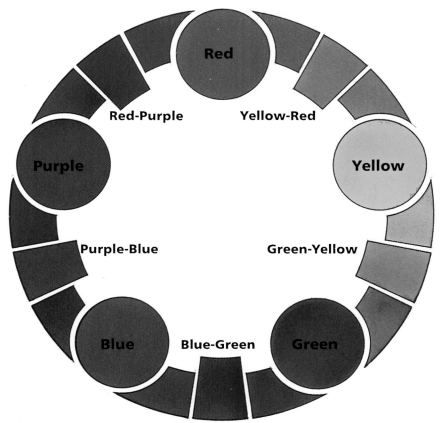

The color wheel, redefined according to the Munsell Color Notation System. Compare this with the triadic color wheel on page 5.

How does all this affect us?

The Munsell system, for artists who use it, can change the way they perceive and use color. Though there are no "new" colors in the Munsell spectrum, relationships between colors are significantly changed—a difference worth noting. Compare the Munsell color wheel above with the triadic color wheel on page 5. You'll see that yellow is much closer to red on the Munsell wheel, as the transitional colors between them occupy a narrower segment. Wider segments are allotted to the transitions from blue to red, and from yellow to blue.

Fishing for complements

The principal consequence of this respacing is to force a redefinition of color complements. The complement of red, for example, is now blue-green instead of green. The complement of yellow is purple-blue. Harley Brown, who adheres to the Munsell system in his work, finds that blue-green is a much more comfortable complement to red than green, and that's the approach he teaches today.

Finding harmony in discords

The Munsell system is also the basis of the concept of "discord" colors.

Discord colors for a given painting are located at two corners of an equilateral triangle on the Munsell wheel, where the third corner is positioned at the painting's dominant color. Thus for a painting whose dominant color is red, the discord colors would be purple/ blue and green/yellow. According to this concept, these colors, used as relatively small accents and in equal amounts, should result in the most pleasing, harmonious color scheme. The concept of discords may be seen in practical use in many of Harley Brown's paintings.

What's the bottom line?

In color, as in so many aspects of our world, no single approach is *the* way. Color is such a subjective phenomenon that it will probably always defy precise definition. Triadic, Munsell—they're merely different ways of trying to systematize it.

A good way to expand your own color horizons is to explore these new color relationships for yourself. As you work with color and become more familiar with it, you may well discover that one approach or another answers your questions, meets your needs, pleases your eye. In any case, it's good to be aware that both approaches exist.

Chapter Twelve
Mixing Media for Color Creativity

Suzette Alsop paints a sunny interior

In 1986, the year Lola and I opened our Gallery At Mill River, Suzette Alsop was one of the first artists to approach us for representation. We immediately fell in love with her work, and with her, and have delightedly watched both art and artist grow and evolve ever since.

Suzette Alsop's paintings, usually combinations of pastel, gouache, pen line and watercolor, are so rich with light and color energies that they communicate instantly and powerfully with an amazing percentage of gallery visitors each summer. She is consistently one of our gallery's best-selling artists.

This morning Suzette Alsop has set up in the living room of our Massachusetts home, facing the sunny corner she has chosen to paint. The floor is protected with a plastic drop cloth and not one, but two, sheets of Arches 140-lb. hot-press paper are ready for use. Suzette studies the scene through a small cutout mat.

Defining the subject

S.A. – I often do two pictures at once, sometimes a vertical and a horizontal.

Standing before her portable table, palette open and ready, she quickly sketches the scene with ballpoint pen, deciding on elements to omit from the cluttered corner, entreating me to get either Charlie or Kelly (our two cats) to pose.

Kelly, as it happens, is having none of it. When I finally convince Charlie to take his morning nap on the blue chair, Suzette quickly does several watercolor sketches on scraps of drawing paper, setting each aside for reference when His Catship decides to move on to other business.

Two good starts are better than one

With a light blue, water-soluble marker, Suzette sketches the scene on one of her two sheets.

Lines, loose and sketchy, are freely restated as her perception of the scene develops. With one drawing completed (let's call it Picture "A"), she quickly begins a second one ("B"), then immediately moves to lay in a wash, allowing the pen lines to bleed. Suddenly, Charlie assumes a particularly appealing pose.

S.A. – Cats are such a dynamic subject, rarely still. I really want to get that while I can, so I'll switch to the other sheet (A), which is still dry.

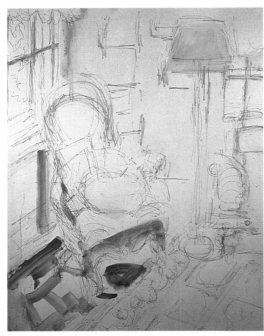

Picture A

Picture B

A subject of opportunity

Quickly mixing French ultramarine and burnt sienna, she paints Charlie's ears, back and tail with a floppy no. 12 round sable. Cerulean blue and gouache white are brushed into the still-wet wash for tonal variation, and Payne's gray is brushed into his ears.

S.A. — The thing about animals is that they can be *in* the picture, but should not *dominate* the picture. Otherwise you have a "pussycat painting."

When she has done what she wants to with Charlie, she goes into chair legs and frame.

S.A. — I've already worked out the colors in my sketch. I usually start with the darks because that establishes my range of values.

Having decided that the outside foliage will call for very strong values, she works into these areas with sap green and Winsor green.

S.A. — I'm always interested in what's inside and what's outside . . . what the light does to things. The window plays a very important role — first of all, as the link between the natural outdoors (which I love) and the indoors (which is our creation and our haven). It lets in the light, and its horizontals and verticals give structure to the picture.

She paints dark green foliage, then goes back into the partially dried washes with a lighter value.

S.A. — I'm thinking about color now more than anything else. In essence, this will be a blue picture. The orange floor will be my color complement, along with the orangey frames on the wall.

Working solely with her blue wash, she begins to establish shadows on the floor. When the sheet is too wet to proceed, she turns her attention to the now dry "B" version. Using a soft 1½" flat, she begins scrubbing a light-value wash over most of the background, omitting only areas that will remain sunlit.

S.A. — I'll paint and pastel over this. But first I want to put in some lines while the wash is still wet.

She uncorks a bottle of waterproof liquid color, her own mixture of ultramarine and turquoise, and picks up an old, splayed-out Speedball flat-nib pen; she dips it fully into the liquid watercolor and begins to draw the corner cabinet and its collection of old chocolate pots, rejoicing in the way it bleeds and spreads into the still-wet wash. That completed, she extends her attention to the chair and window, pen-lining outlines and details.

Picking up her brush, she then works downward across the floor, returning to refine Charlie's pose and to lay in and key lighter elements on the chair back and side, as well as on the curtains, lampshade and sofa.

Back to Charlie again, she washes in shadows and details. Finally, she shadows in the rug, adding pattern with her pen.

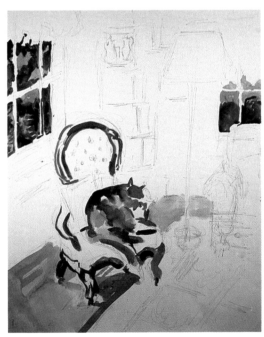

Picture A

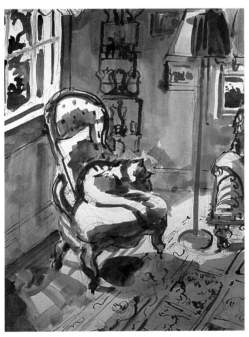

Picture B

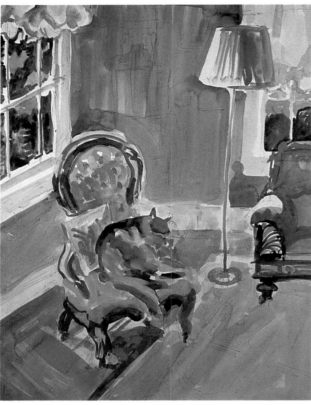

Picture A

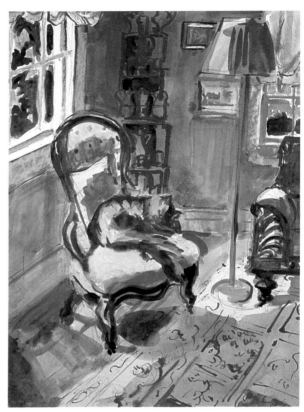

Picture B

Color statements

Back to painting "A" now, red is brushed into the sofa, then a deeper alizarin crimson is added. Next she proceeds to its dark outlines.

She moves to the window curtain at right, creating its shadowed translucency. The curtain at left gets a similar treatment, with added notes of Winsor violet. Shaded mullions and window frames are brushed in with Winsor violet mixed with permanent rose. The pink hue becomes more visible as baseboards are added to the left and right of the chair.

Finally, Suzette lays in the large blue mass of the background wallpaper.

L.L. – I've always envied your ability to lay down color so boldly and freely, and just let it alone.

S.A. – I pay for that later, you know, with hours and hours of very careful and (hopefully) unobtrusive corrections.

L.L. – Have you always worked this loose?

S.A. – My mentor for many years has been Stockbridge, Massachusetts artist Leo Garel. One of the ways he got me to loosen up was by having me work on wet paper. He encouraged me in that direction. But I still turn out overworked things all the time, even now!

She lays in the light wash of the carpet and adds color in and around the chair, closing out almost all the remaining white. Moving to still-slumbering Charlie, she blends opaque values of yellowed white into the dark of his fur.

Adding pastel

Placing the paintings side by side, Suzette eyes them critically.

S.A. – Right now I like "B" much better! Going from one painting to the other, I'm able to see each one anew. I can also do something on one and get an idea whether it

might work on the other. That way each painting helps the other.

Rummaging through her pastel box, she comes up with a stick of Mars violet, with which she scrubs in shaded window frames and mullions, and warms the woodwork beneath the windows and along the baseboards. Raw sienna pastel warms the window frame at right. Returning to her 1½" brush, she darkens the blue of the wall to bring out the brightness of the light, she says. Satisfied, she turns her attention to the orange of the floor. First the shadow tones, then the brighter sunlit areas.

S.A. – The brightly sunlit patches I'll put in with pastel. Mixing media with pastel, I can bypass the limitations of watercolor.

For me, though, the danger is using too much. If the pores of the paper get choked with pastel I can end up with a heavy look.

The orange floor hue is repeated on the chair frame, then

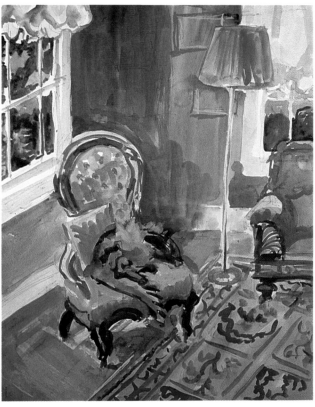

Picture A

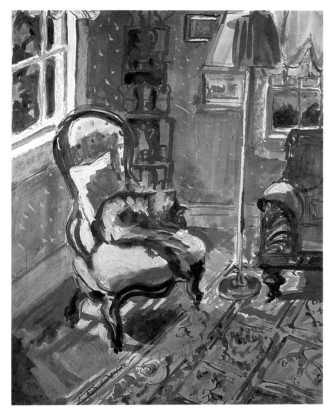

Picture B

red is added to the sofa. Dark values follow for the fretwork and frame. Back to pastel, she strokes raw sienna into the window frame, brass lamppole, curtains, baseboard and picture frames. A touch of red picks up the sofa hue in a picture frame. Gouache white softened with blue is brushed into the chair. While it's still wet, she strokes in light blue pastel.

S.A. — If you want it to be dark, you work into the wet paint. If you want it to be light, you wait until it's dry.

L.L. — I notice you mix your media not only to create lighter notes in dark grounds, or dark in light, but also just to achieve strong color.

S.A. — Yes. Especially when I can't get what I want with paint.

I still don't think the corner cabinet is dark enough. If I lighten the chocolate pots, they'll be too obtrusive, so I'll darken around them, keeping them the present value.

Into the homestretch

Working much more loosely in version "A," Suzette paints dark details on Charlie, adjusting to his latest pose, blending to create the warm grays she sees. She uses her pen to restate the chair frame, returns to gouache blues for the chair pillow. While the washes are drying, she builds shadow shapes around the chair to bring it forward.

When the chair washes are dry, she uses pastel to block in the highlighted blue, then picks up her brush to darken the background around it. Pastels are used for picture frames, and a smaller sable brush is used to lay in rug patterns.

S.A. — There's that fine line between not enough detail and too much detail. I try not to use too fine a brush.

Shadows are added to the chair as value relationships are adjusted. Pastel highlights are added to the

rug, and bright orange pastel goes into the floor.

Neck and neck

Pattern is added to the rug with ultramarine and raw sienna washes. Then switching to pastel, the artist continues to work around her previous washes. A strong stroke of light sienna becomes the lamppole and bright sunlight between the chair legs. Dark sienna accentuates shadows. Orange catches reflections on the chair legs.

S.A. — I'm wondering about the wallpaper.

Taking up a light mauve pastel, she starts to dot in the pattern. She must approve, because she completes it, quite loosely, then moves on, adding pale pink highlights to the chair cushion and to window frames, reducing the glare of the white. By now the sun, and Charlie, have departed, and the artist calls it a day.

Picture A

Picture B

Down to the wire

Suzette has taken both paintings home to work on them in the quiet of her studio. A few days later, she returns. I ask her how she feels about them now.

S.A. — In some ways, while I didn't like it as well, Picture A had the better arrangement. So in B I lowered the curtain at left and moved the pillow on the chair. I also made the shadow bigger and darkened the top corner of the room because I liked the way that worked on A. Also, I widened the corner cabinet and straightened some of the lines (mostly with pastel).

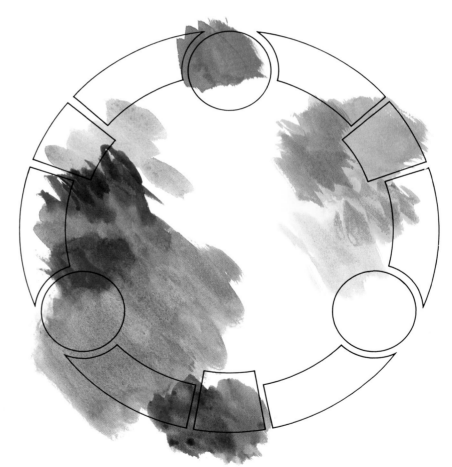

The Color Dynamic for *Charles's Corner*

With blue the dominant color in this painting, orange becomes the color complement. Notice also the secondary red/green color complement at work here.

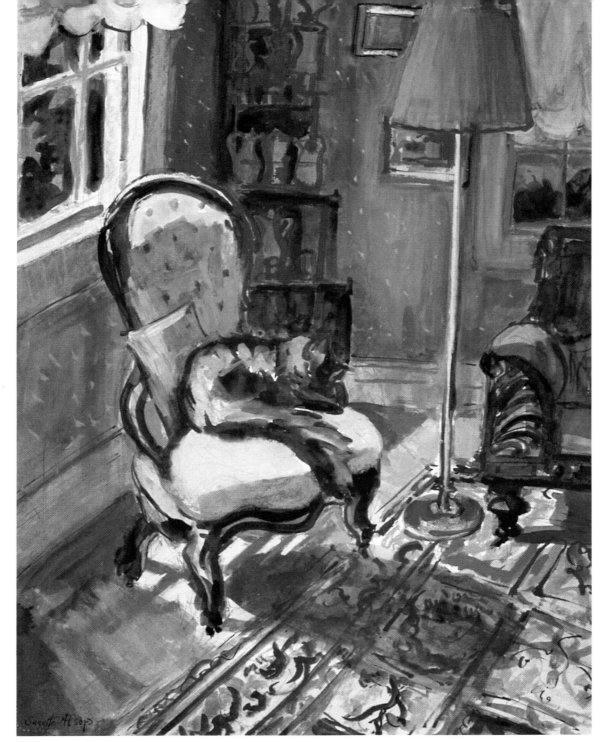

Picture B

And the winner is . . .

In finishing Charles's Corner, *Suzette darkened much of the background; she toned down the light in the wallpaper, shadowed floor, lampshade and curtain; further focused attention on chair and Charlie; and brought out the sparkle and warmth of the sunshine.*

S.A. – To me, painting B is the more successful one. I'm just not as happy with the overall impact of A. I'd work on it more, but it would just get to look more like B. And what's the point of painting two identical pictures?

In a way, you know, I think my little sketch is the most successful of all, which is so often the way. Somehow the first time it hits you, and you get it down on paper . . .

Charles's Corner
Suzette Alsop
Mixed media
30″ × 22″
Collection of Lola
and Lew Lehrman

Summer Bouquet
Suzette Alsop
Mixed media
24″ × 19″
Private collection

The essence of a summer's day is captured in this light and airy composition. Light values in the flowers play off against darks in the outside foliage. Stronger value flowers contrast against the loosely stated wallpaper.

No shadows anchor vase to table, enhancing the breezy, floating sensation this painting imparts. Media include watercolor, gouache, and just a touch of pastel and pen line.

The Striped Awning
Suzette Alsop
Mixed media
22″ × 30″

One can almost feel the sun's heat streaming into this brightly lit painting, rich with textures of watercolor and pastel.

The artist has chosen to place her deepest values in the distant trees, outlining them with red, their most intense complement, to evoke the shimmery heat of a summer day. Even the green of the lawn is shot through with high-key reds. Intense blue in the foreground offers cooling relief from the heat (almost like plunging into a pool) by restoring color balance to the composition.

Amaryllis and Fireplace

Suzette Alsop
Mixed media
30″ × 22″
Collection of Lola
and Lew Lehrman

A triadic (red, yellow, blue) composition, *Amaryllis and Fireplace* is a wonderful example of the use of value to enhance color. The bright red flowers achieve maximum intensity against the sooty fireplace. The bulbs contrast against the dark green pot. The table itself contrasts strongly against floor and rug, except where it merges with the dark mass of the fireplace, creating the vertical zigzag pattern that moves the eye through this painting.

As with most of Suzette Alsop's paintings, perspective is stylized—or denied entirely—and lighting becomes less important than color and composition. Keeping everything up front on the picture plane, her paintings are successful not only as representational art, but as abstract design as well.

Pink Peonies

Suzette Alsop
Mixed media
22″ × 30″
Collection of Marcia
and Joseph Bernstein

This bold interior is a darkly analogous blue/green/yellow composition, with the strongest contrast coming from the light (value contrast), pink (complementary color) peonies. Note how brightly the broadly stylized bowl, vase and flowers stand out against the painting's darkest value—the green of the foliage—and against the blue of the table.

The deep blue was added, says the artist, "in desperation over dullness. Suddenly the painting came alive with contrast, enhanced, I like to believe, by the struggle underlying it."

A substantial amount of pastel has been worked into nearly all areas of this piece, which was painted in watercolor and gouache.

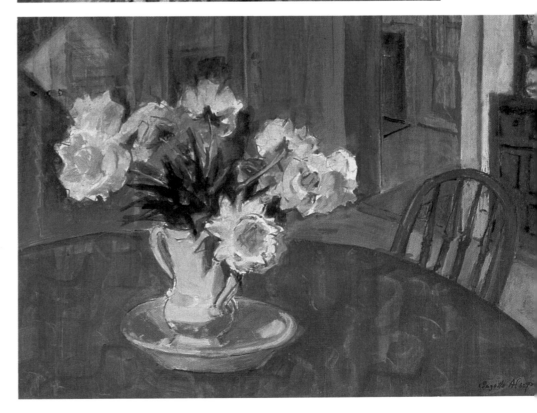

Chapter Thirteen
Pushing Color to the Limit — and Beyond!

Donald Putman paints firelight

As artists, and as art spectators, we're accustomed to seeing certain colors in certain places. Shadows on a sunlit surface, for instance, are often seen as sky-lit blue. It's easy to simply darken a color to shadow it, so we do. The formula may work, but the effect is predictable — uninteresting.

Master colorist Don "Putt" Putman takes color well past the limits of the predictable, as we can see in any of his paintings: startling, dramatic color combinations that somehow look inevitably right; analogous, nearly monochromatic, compositions that bowl you over with their intensity; brilliant complementaries that unexpectedly blaze out of shadows.

Putt has spent most of his life in art developing and perfecting his approach to color, and he articulates it forcefully and well.

1

The setup

Putt comes to my Scottsdale studio laden with stuff he's brought for his workshop week at The Scottsdale Artists' School: Native American costumes, artifacts, blankets, hats, props, and headdresses. Knowing that excitement with the scene translates to excitement on the canvas, Putt provides his students with dramatic, colorful setups. His model, Native American (part Dakota, part Assiniboine) Katherine Mackey, has changed into a soft buckskin dress and settles into the setup, while Putt arranges props, lighting and cushions.

Initial drawing

Putt's initial drawing is done with an Expresso nylon-tipped pen. Somewhat waterproof and nonbleeding, it's ideal for the oils he's using today, or for acrylics, and the strong, black line will easily show through the initial lay-in of color.

Putt sees this as a diagonal composition, with the model's head at upper right. He begins there, omitting the features.

D.P. — I'm already visualizing my color scheme, even though I'm not yet dealing with color. Firelight dictates an amber-toned picture, so I know that violet — the complement of amber — will be very important. Violet elements in the painting will come forward.

The basketry and dolls in the foreground will help to create a secondary center of interest.

Planning and editing

D.P. — While it's important to be as accurate as possible with drawing, you don't necessarily want to paint that way. You want to paint it *better* than you see it. So you "cheat." You make it *more* (or less) contrasting in value. You change things. You edit a lot. Just like a writer, what you *don't* say is often as important as what you do say.

Take this painting. I want to establish a firelit mood. So I'll key it in warm red tones. All my whites — the beading, blankets, and so forth — will be reddish whites. All my darks — her hair or the patterns in the blankets — will be reddish black. Even the flesh will have a reddish tone. This will pull the whole painting together. If I were to paint all the colors I see — the greens in the blanket, the blues,

and all that — my result would be too garish.

It's important where I put the least-red whites and the least-red darks. I'll put a little blue in the darks of her hair, but all the other darks will be red-darks, and none will be as dark as her hair. That way I have control over where the viewer will look first.

Putt's point is worth noting. The area that contrasts most strongly with the dominant color of the painting will become the center of interest. But keep in mind, says Putt, that where you place the center of interest depends on what you're trying to say in the painting. The emphasis here is on how beautiful Kathy is, so her head is very important.

D.P. — Sometimes it helps to come up with a title before you start because that suggests colors, textures and theme. A title for this painting might be "Waiting Maiden." This immediately gives me ideas for color and mood.

2

3

The first scrub-in— covering the canvas

Putt attacks his canvas vigorously, using his preferred "fitch" brushes. Favorites of sign painters, they recall Putt's days as a scenery painter with MGM. He wields these flat, angled bristle brushes as he does his drawing pen, business end up, bristles angled obliquely toward his canvas.

His first color, a vibrant, red wash liberally diluted with matte varnish, is scrubbed in at top right. A reddish-orange wash goes in at lower right, without regard to the drawing, which shows clearly through the transparent glaze. Joining the two areas, he creates an exciting, vigorous transition.

D.P. — There always has to be a color change or a value change or a texture change from one area to the next. The eye won't move without that. Where paint is all the same color, it creates a dead spot. If there's no gradation in the subject, you have to invent it.

He scrubs in violet at top left, blending it with the red. Then, adding ultramarine, he carries the wash down the left side.

D.P. — At this point I'm essentially an abstract painter, simply trying to make an interesting, exciting canvas before I even start on Kathy.

I want to get the whole canvas covered at the outset because the white of the canvas can cause me to key my painting incorrectly.

Establishing the darkest values

D.P. — It's important at this stage to establish some darks. So I'm starting off with brown madder in the right side of the hair. The right side of the painting will be the warm side. The left will be the cool side (as well as the less-complicated side). I'll add a little blue there.

Working on the left upper torso, Putt begins laying in opaques, beginning with cool blue at the extreme left edge and blending in Naples yellow as he moves right, toward the hair. He continues to warm the tone as it proceeds across the chest, adding a much lighter shade of the Naples yellow at the right shoulder.

D.P. — These buckskins have a kind of greenish tint to them. That will tend to bring out the warm red

tones around them. Remember that whatever color you use, it pushes the adjacent color toward its complement. Green next to red will make the red look even redder.

Many of the color choices that Putt makes in the course of painting are based on decisions he made at the very beginning. As he constructs the painting, these differences will be emphasized— "pushed"—much more than even the most sensitive observer would note in the setup. In this manner the subtle contrasts in color, value and detail are made visible to the viewer.

4

5

Bringing the painting up

Having established basic values and colors, Putt works to develop the whole painting, working over the entire surface. An intense red is brushed into the right of the skirt, then grayed tones, which suggest the blanket she's sitting on, are added. He cools the color of the blanket as he proceeds down beside the leg. To the left, away from the firelight source, the tone turns still cooler and darker, as he moves to lose the blanket's edge against the skirt. Dark reds loosely suggest the pattern of the blanket.

D.P. — I want to establish some of the real warms on the right side now, so I'm adding Naples yellow to the background, allowing some of the underpainting to show through.

Putt continues, brushing in darker violet tones to the left of the head, blending it with the hair and softening its edges, then he moves down along the shadow side, losing edges as he goes.

Developing the facial features

D.P. — I begin the face like a sculptor, trying to capture Kathy's likeness as she might look from a block away. Keeping in mind that Kathy is Native American, I will key the fleshtones rather dark. Brown madder and white will give me a kind of purple tone, which I'll warm up with oranges and yellows where the blood runs close to the surface — elbows, nose, wrists, cheekbones, etc.

A very soft, cool red, though warmer than the fleshtone, is used for her mouth.

D.P. — I'm really sculpting the form here to get the structure of the head. Squinting simplifies the lights and darks.

To emphasize the "firelight" I add greens in the shadow side of the face, which will push the sur-

rounding colors toward red. For this to work, the green must be nearly the same value as the surrounding colors.

Now working on the torso, Putt adds more greens in the shadows. This startling use of color is a hallmark of Putt's painting style.

D.P. — Emphasizing the green tones in the shadows will force a real "heat" effect on the right. But it's also important in order to keep my painting as impressionistic as possible, to make it really effective without tying down details.

Closing in on the finish

Switching to a small sable round, Putt then begins refining the shape of the right eye; highlighting the tip of the nose; lightening forehead, chin and neck; adjusting shadows on the lips.

Finally, Putt turns his attention to the background; he defines blankets and baskets, and blends the edges of the background and figure.

At this point Putt feels he has taken the painting as far as he can "on location," having defined values and established color harmonies. Now he'll take the painting home, study it awhile, then finish it, using photos he has taken as reference.

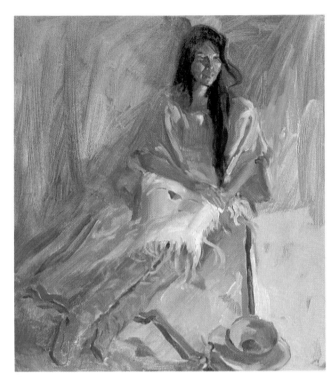

6

The Color Dynamic for *Waiting Maiden*

A richly analogous color scheme runs from violet to yellow, with just a few green highlights.

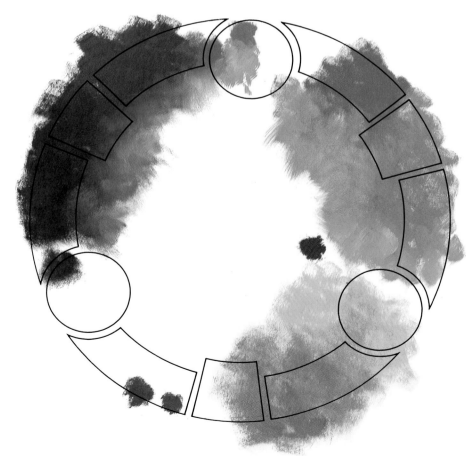

Waiting Maiden
Donald Putman
Oil on canvas board
24″ × 18″

The finished painting

D.P. — After looking at the painting for a while, I decided the baskets were too crowded in the composition, so I moved them into the negative space and made them a little larger. I rendered the face a little more and softened the cheekbone. I added detail to the beading on her costume with some intense greens.

L.L. — Is there a guiding principle to your "end-game"?

D.P. — From the time I took the unfinished piece away with me, my main objective was to take my "demo" and turn it into a painting. That is, to express what I *felt* about the scene, rather than merely what I saw. To me, that is the essence of painting.

Pushing Contrast
Putt's key to painting excitement

The excitement that comes through in Putt's paintings has its beginnings in his careful orchestration and manipulation of contrasts: simple area against complex area, warm side against cool side, texture against smoothness.

D.P.—Contrasts put drama in the story you're telling, whether in a novel, in music, or in a painting. The heroic cowboy, surrounded by cowards, looks even more heroic. In Hemingway's *The Old Man and The Sea*, the old man is made to seem older by being contrasted against the young boy. The giant fish is made to seem even more menacing by its contrast to the tiny, frail boat.

Your job as an artist is to build upon the contrasts you know are there, to make your painting stronger. Look for subtle color changes. If you can see them, push them even further. If you don't see them, create them!

The eye is attracted to what there is the least of in a painting. Bringing out contrasts—or creating them—is an important part of your task as an artist.

Conventional wisdom holds that warm colors advance and cool colors recede. That may be true in the real world, but in your painting you can make it just the opposite. In an orange painting, for example, blues will catch the eye—they'll advance. In a very gray painting, intense colors will do the same.

Take that a step further: In a very smooth painting, texture will attract. In a very simple painting, detail will. And the converse is true in every case!

Crow Fair
Donald Putman
Acrylic on yellow
Canson paper
20" × 24"

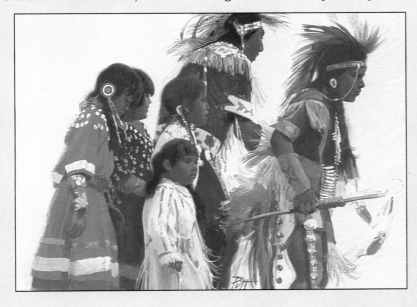

Putt's painting is a study in contrast, both in vigorous color and in choice of subjects. The youth and vigor of the children, excited about the fair, are contrasted with the old man in the background. The color contrasts are also intense, reflecting the artist's vivid impressions of the Annual Crow Fair in Montana.

The figures, intensely back-lit by the yellow of the paper, are thrown almost into silhouette. Their fleshtones tend a little toward violet, an effect Putt likes to push even further. Note how some of the shadowed whites are blue and some are purple. It is this variety of colors, warmer and cooler, that keeps the eye moving across the lively surface of this painting.

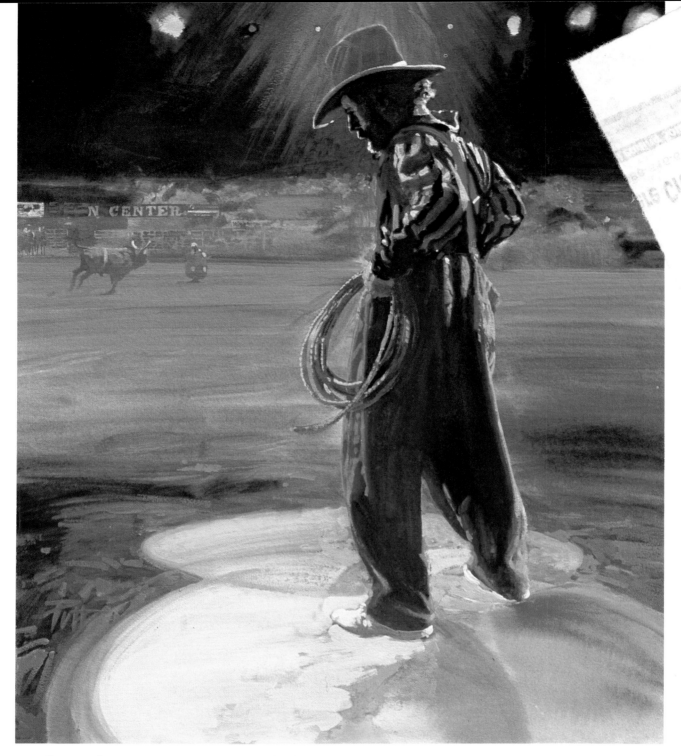

Guardian Angel
Donald Putman
Acrylic on water-
color board
30" × 24"

The rodeo clown *is* the bull rider's guardian angel. He has to know every bull, every rider. He has to know how to get the bull's attention and keep it away from the fallen rider. It's hard, dangerous work.

All the brilliant lights you see are the original lay-in of color, right out of the tube. Then Putt came back against them with strong, dark values of their complements for maximum contrast. Note reds beside greens, orange lights against blue background.

Note also how the man is back-lit, his light edges bleached out and simplified. All the detail is in the shadowed areas, just the opposite of what you'd normally expect. This is one of the key reasons the back-lighting effect works so well here.

Cabaret
Donald Putman
Acrylic on Canson
paper
30" × 24"

The colors in this painting help set its mood of delicacy and vulnerability. This is essentially a pastel-toned painting, for the colors are all close in value. The strongest values are seen in the beer bottle and the hand. The young lady, who was modeled by the artist's niece, is painted rather ruggedly for a woman. But the background is even more rugged, so she still appears quite feminine. She's also back-lit, so her face is in shadow, lending a bit of mystery. The intense colors present in this painting serve to make the other colors look even more subtle.

Australian Brick Bakers
Donald Putman
Acrylic
30" × 40"

This painting features an analogous color scheme, running from orange to red to violet. The artist chose to make the scene even redder than it actually was to emphasize the heat and smoke he observed. The blue highlights serve only to push the red to greater intensity. The furnace openings, which seem almost to glow from within, first were painted white, then were glazed to bring out the color of the flames. Notice how blue was added to the bricks around the furnace openings to make the contrast even stronger.

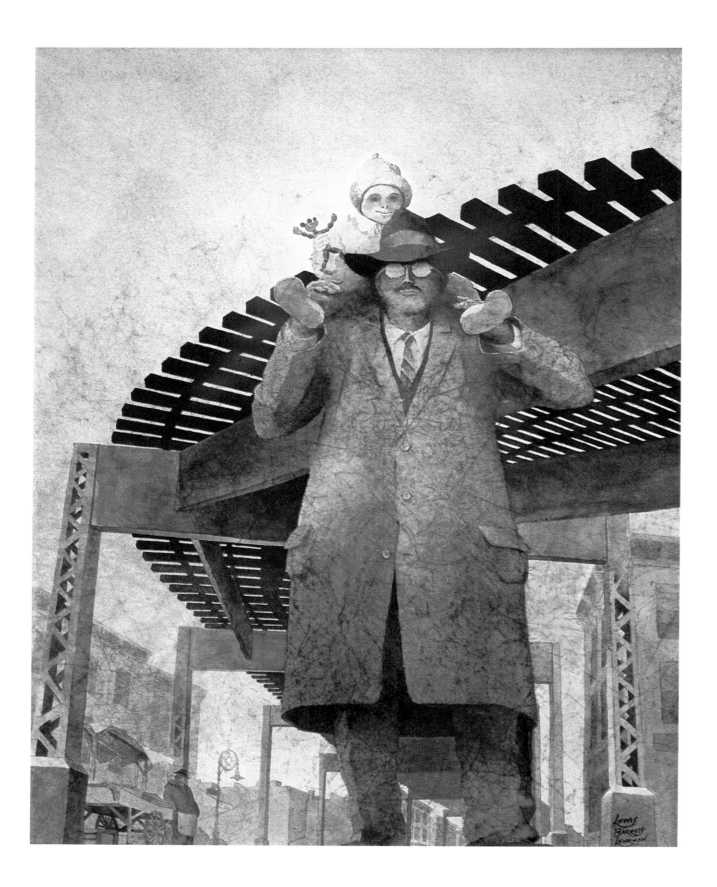

Conclusion
The Last Word

Pop and Me
Lewis Barrett Lehrman
Watercolor
30″ × 24″
Collection of the
artist

This painting, drawn
from the author's child-
hood memories, is of-
fered as proof that to
"energize" with color
means far more than
merely pumping up its
intensity.

The near-monumen-
tal figure, seen from
ground level, is framed
by the hulking form and
dark values of the ele-
vated train tracks. Both
are strongly contrasted
against light-valued, del-
icate hues of sky and
background. Blue, as ac-
cent color, serves to sep-
arate the child from sur-
rounding elements.
Below, siennas and yel-
lows are contrasted
against complementary
blues and purples, sug-
gesting the patina of fad-
ing, old snapshots.

I hope you'll find that you've gained as much from
reading *Energize Your Paintings With Color*
(particularly if you've been painting along with some
of the demos) as I have gained in writing it, watching
all these wonderful artists at work, picking their
brains, and asking the questions I thought you'd have
asked.

Color is a tenuous, intuitive, often elusive concept.
Some artists I know tell me it just can't be taught. I
disagree. I've been working with color for over forty
years, and still I'm amazed at the insights and
information I've absorbed, simply in the process of
putting this book together.

The bottom line, if there is any, is that the process
of becoming fluent with color is much like learning
any other language — since that's precisely what color
is: a visual language! Mastering a language depends
on becoming familiar with the vocabulary and
grammar (remember the title of chapter 1?), hanging
out with a crowd of people you respect who use the
language constantly (they're right there in chapters
2 through 13), and then using the language yourself
as frequently as possible.

Which is where my part ends, and yours begins.

— Lew Lehrman

The Artists

Joe Abbrescia

Joe Abbrescia is a native of Chicago, where he founded the Village Art School in Skokie, and directed it from 1965 to 1976. Today Joe and his wife, Sue, a talented ceramicist in her own right, divide their time between Scottsdale, Arizona and Kalispell, Montana, where he enjoys painting the impressive scenery of Glacier National Park. Joe Abbrescia's work is exhibited in galleries in Colorado, California, Montana, Illinois, Wyoming, Arizona and Massachusetts. He is well known as guest lecturer at the American Academy of Art, was Artist of the Year for the American Royal Art Association, and has had a one-man show at the Museum of the Southwest in Midland, Texas. He still gives painting classes and workshops. His painting *Spring's Mountain Kingdom* was chosen as the 1990 fine art limited edition print for Glacier National Park's Art Collections.

Suzette Alsop

A sickly child, whose mother was a devoted artist, Suzette Alsop spent a large part of her childhood in bed, where her love for drawing and painting developed. She received her BFA from Radcliffe College, where she participated in their Museum Curatorship course. When she married attorney Robert C. Alsop, they moved to the Berkshires of western Massachusetts, where they raised their four children. When the children reached their teens, Suzette enrolled at the National Academy of Design, where she studied for several years, receiving a number of prestigious awards and prizes. She has actively pursued fine art ever since. She endeavors to paint daily, working in a variety of media, including oils and collage. She exhibits primarily in Berkshire galleries and regional exhibits, where her work has gained wide recognition and popularity.

June Allard Berté

June Allard Berté and her husband, Ray, make their home in Enfield, Connecticut. She maintains her studio in a renovated loft in downtown Springfield, Maine. June began her art career with study at Traphagen School of Design in New York, then moved to Connecticut where she spent many years in the commercial art field as a successful illustrator and designer. One day in the winter of 1980 she realized her destiny lay in the field of fine art. She refers to that moment now as her "personal epiphany." Since that day she has, as she puts it, "repeatedly invested in self," to become proficient in painting and to market her considerable skills. Though portrait commissions demand a major share of her schedule, she also enjoys genre painting. Her work is shown at galleries in Arizona, Massachusetts, Florida and Ohio.

Harley Brown

A totally dedicated devotee of pastel portraiture who, by one estimate, has done "a hundred thousand heads" in his time, Harley Brown is well known throughout the West. A native of Canada, Harley attended the Alberta College of Art, and the Camberwell School of Art in London, England before embarking on a long and arduous struggle to establish himself as a professional. Brown and his wife, Carol, spend most of their year in Tucson. He is a member of The National Academy of Western Art, having received five gold medals since 1977. Eager to share his knowledge, Harley conducts an invariably sold-out workshop series at The Scottsdale Artists' School each year, and, together with fellow artist and close friend Tom Hill, guides an occasional workshop group to exotic destinations.

Joni Falk

Born and raised in Chicago, and a graduate of Marquette University, Joni and her husband, Bob, moved to Phoenix, Arizona in 1960, where they established a small crafts shop. Her involvement with teaching both crafts and tole painting at the store converged with a growing passion for Southwest culture and history, and she began a series of miniature paintings of Native American pottery. These paintings provided entreé to the gallery scene, and her interests, and career, have grown steadily ever since.

Joni has been the recipient of numerous gold and silver medals for her work, including the Old West Museum's Purchase Award at the Governor's Invitational in Cheyenne, Wyoming. Her work has been profiled in *Art of the West*, *Southwest Art*, and *Art West* magazines, and may be seen on exhibit in galleries in Arizona and Wyoming.

Ted Goerschner

Following graduation from the Newark School of Fine and Industrial Arts and two years in Korean wartime service, New Jerseyan Ted Goerschner followed his parents to Florida, where he attended Tampa University and immersed himself in the then-popular abstract expressionist movement. In the early sixties, he returned to New York to pursue a career as a commercial art director, attending classes at the Art Students League. During this time his work evolved into the loose, impressionistic style for which he is best known today. After leaving New York to study and paint for several years in Vermont, and then Rockport, Maine, he wound up in California, where he lives with watercolorist/wife Marilyn Simandle, a son, two dogs and two cats. Always busy, Ted conducts numerous far-flung workshops, produces and markets the couple's instructional videos, and still finds time for his passion: plein air painting.

Raleigh Kinney

After obtaining his master's degree from St. Cloud State University in Minnesota, Raleigh Kinney taught in the Minnesota public schools for fifteen years before deciding to change the direction of his life. He currently resides in Tempe, Arizona, where he devotes full time to practicing and teaching watercolor and conducting workshops and classes regionally and in more than fifteen western states. He is founding member, signature member, and was first vice-president of the Midwest Watercolor Society. In the past twenty years, he has been juried into over forty-eight American and Canadian exhibitions, and has earned many best-of-show, merit, and purchase awards. Raleigh, together with his wife, Darlene, markets his work primarily through Southwestern fine art shows, where they may often be seen wrapping another of his colorful paintings or prints for a happy purchaser.

Lewis Barrett Lehrman

Watercolorist/author Lew Lehrman comes to fine art following nearly three decades in commercial art and illustration. Together with his wife, Lola, the Lehrmans ran Design Unlimited until 1984. It was a graphic design and food service consulting firm known nationally as one of the most creative firms in its field. These days the Lehrmans reside in Scottsdale, Arizona, having recently sold their home and the art gallery they both operated in the Berkshires of western Massachusetts. Lew's first book, *Being An Artist*, was published by North Light Books in 1992. It was inspired by his own interest in learning what it takes to become a self-supporting, professional fine artist in today's world.

Lew received his graphics and fine art education at Carnegie Institute of Technology, and at Pratt Institute in New York. Lew's work is currently on exhibit at galleries in Arizona, Connecticut, New York and Massachusetts.

Gerry Metz

When the conversation gets around to art and artists who personify the West, Gerry Metz's name is generally among the first mentioned. A native of Chicago, Gerry was an art school dropout who unexpectedly landed a job at one of the city's better art studios. This prompted him to return to school, where he enrolled in night classes for the next four years. Gerry took his experience to Arizona in the early seventies, where he briefly ran a small art school. Today, he lives comfortably in Scottsdale, Arizona with his wife, Dayna, and their four sons. A disciplined, hardworking artist, Gerry still finds time to actively participate in charity, community and family affairs. In addition to his popular paintings, he has successfully issued a number of bronze sculptures in limited editions. His work is exhibited through galleries in Arizona, California, Indiana, Wyoming and New York.

Donald "Putt" Putman

Following an excellent education at The Art Center College of Design in Los Angeles, California, Don Putman embarked on an almost unbelievable odyssey which led him cross-country to a job on the Ringling Brothers circus train, to the jungles of South America, back to the United States and a near career as a top circus clown, to the busy scenery shop at MGM, to a faculty career at The Art Center, and ultimately to the fine art he pursues to this day.

Putt is a creative and prolific artist whose work may be seen at galleries and in collections throughout the Southwest. A patient, creative and articulate professional whose knowledge of color is comprehensive, he now limits his teaching schedule, primarily to a well-attended week at The Scottsdale Artists' School each year. He lives with his wife, Bobbie, in California, not far from the western edge of Yosemite National Park.

Marilyn Simandle

Born in Toledo, Ohio, Marilyn Simandle earned her BA degree in commercial art and illustration from San Jose State University. Her fine arts career began in 1969, and since then, her watercolors and acrylics have earned her over forty-five one-woman shows and numerous prestigious professional awards. Most recently, she became the recipient of the 1991 "High Winds" medal, from the American Watercolor Society.

Marilyn's studio is on a ranch in southern California, where she lives with artist/husband Ted Goerschner and their son, Nathan. She occasionally travels to paint on location in Europe or elsewhere, or to conduct workshop classes in historically significant locations in California, and in Scottsdale, Arizona. Her work is exhibited in California, Arizona and elsewhere. Prints of her work are featured through Art In Motion, a leading publisher of fine art reproductions.

Peter Van Dusen

Born in New York, Peter received his master's degree in physical geography from the University of Oregon, and his doctorate in geography from the University of Michigan. Much of his preartistic career was spent teaching ecology-related courses, conducting environmental research, planning land use and illustrating scientific manuals. Peter's transition from scientific illustrator to fine arts professional was an outgrowth of his desire to share his deep love for the rich variety of America's land. Today he is a full-time artist, living and working in Scottsdale, Arizona with his wife, Mary.

Peter's major artistic interests are the Southwest and Hawaii, though his subjects encompass many parts of the country. His work is featured in private collections throughout the United States, Germany and Australia, and is exhibited at galleries in Arizona, New York and New Mexico.

Index